Francis Bacon

Francis Bacon

In conversation with Michel Archimbaud

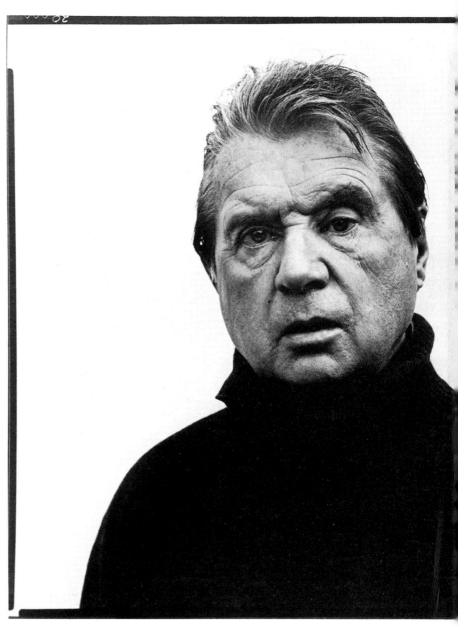

1. Richard Avedon: Francis Bacon,
Paris, 11 April 1979

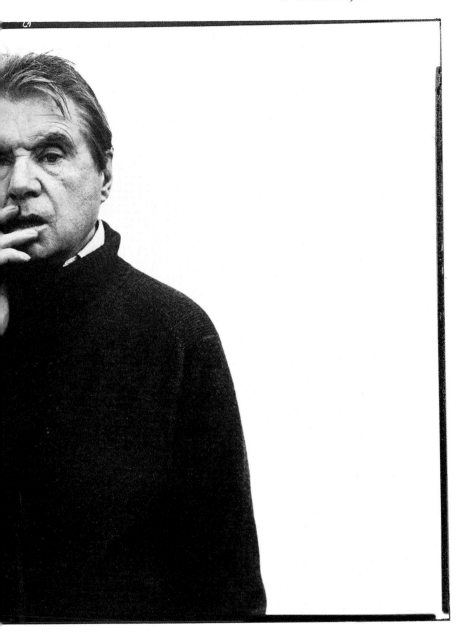

To the memory of Francis Bacon

Phaidon Press Limited
Regent's Wharf
All Saints Street
London N1 9PA

This edition first published 1993
Reprinted 1998

© 1993 Phaidon Press Limited, English translation
© 1992 Éditions Jean-Claude Lattès

ISBN 0 7148 2983 8

A CIP catalogue record for this book is available
from the British Library.

Printed in Singapore

Contents

Preface

From our first meeting in 1987, my conversations with Francis Bacon were conducted in French. It was a language which gave him enormous pleasure, because it evoked a country and moments of his life which he particularly cherished. In the autumn of 1991, during the filming of our conversations, the artist shared many things with me in an extremely spontaneous way, in his studio as well as in the street or in a bar, and only very few words were spoken in English.

The text of these conversations has been constructed from recordings of those meetings which took place between Francis Bacon and myself from October 1991 to April 1992. They were due to continue in Paris where Francis Bacon intended to go after his stay in Madrid. He died in Madrid on 28 April 1992.

Michel Archimbaud

Acknowledgements

The publication of this book gives me the opportunity to thank:

Pierre Boulez to whom I owe my meeting with Francis Bacon; Mrs Valerie Beston of the Marlborough Gallery in London for the friendship she has shown me; Laurent Bayle who welcomed me into the bosom of the IRCAM review, *Inharmoniques*; Francis Giacometti, my friend and accomplice; Jérôme Hébert; Caroline Le Gallic; Eric Adda for the care which he put into establishing the text of this book; and finally Françoise Posselle who, thanks to her knowledge of painting, helped me a great deal in preparing these interviews.

first conversation

2. Marc Trivier: Francis Bacon's
Studio, London, 1980

3. John Deakin: Francis Bacon,
c. 1962 (overleaf)

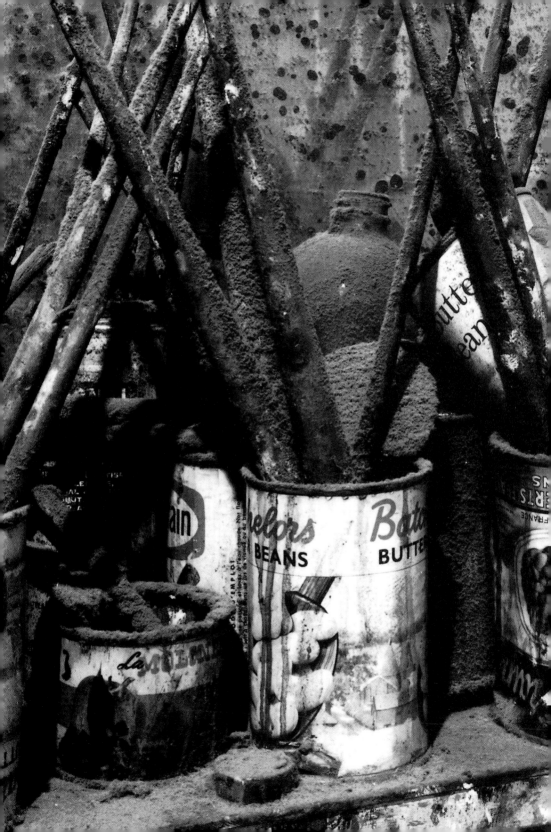

MA We're in your studio; on the walls and all around us there are photographs. What does photography mean to you? Is it an art form in its own right or is it more a documentary source for your work?

FB Photographs are only of interest to me as records. Of course some photographers are artists, but I'm not particularly interested in that aspect of photography.

MA Nevertheless, you have often used photography in your work, haven't you?

FB Not exactly. I know people think I've often used it, but that isn't true. It's only because I've been the first to admit to using photographs that people think I have used it a lot. But when I say that to me photographs are merely records, I mean that I don't use them at all as a model. Do you understand? A photograph, basically, is a means of illustrating something and illustration doesn't interest me.

MA I understand, though, that at one period photography was very important to you?

FB Yes. At one time I did look at many photographs, all sorts of photographs.

MA Which struck you most?

FB Oh, I don't know … news photographs, photographs of wild animals, Muybridge's photographs, scientific photographs, like those in this book on diseases of the mouth, which I found in Paris a long time ago, and which I found enormously interesting …

MA And photographs by Muybridge?

FB Yes, the ones showing the elements of motion. They really did interest me greatly. At one time I spent a lot of time looking at those pictures.

MA As evidence of the distortion of bodies in motion?

FB Oh no. I do that myself. That's not taken from photographs.

MA Nevertheless, the analysis of movement through photography has been very helpful to painters, such as Degas, hasn't it? For example, in studying the way horses gallop?

FB Yes, but not to me. You know, since the invention of photography, painting really has changed completely. We no longer have the same reasons for painting as before. The problem is that each generation has to find its own way of working. You see here in my studio, there are these photographs scattered about on the floor, all damaged. I've used them to paint portraits of friends, and then kept them. It's easier for me to work from these records than from the people themselves; that way I can work alone and feel much freer. When I work, I don't want to see anyone, not even models. These photographs were my *aide-mémoire*, they

helped me convey certain features, certain details. They were useful to me simply as a tool.

MA Would you say the same of the cinema? Has it been of any use to you?

FB Oh yes, but it's a little different. There are some films that I've liked a lot. Perhaps they've had an influence on me. *The Battleship Potemkin* by Eisenstein, for example, made a great impact on me when I saw it. You remember that scene where the child's pram rolls down the steps, that screaming woman, and the rest of the film ... Oh, yes, cinema is great art! Of course, during the silent era, the image had tremendous force. The images of silent film were sometimes very powerful, very beautiful. You know, I've often said to myself that I would have liked to have been a film director if I hadn't been a painter.

Unfortunately, there have always been financial problems with making films. Take Eisenstein, for example. At the beginning, the Soviet

government financed him and that was how he was able to make his first films. It was also propaganda for the new regime, but he did nevertheless make some great films. That didn't last long though, and he had to look urgently for other finance. It's true that people who give you money nearly always want to interfere with what you're doing. *Que viva Mexico*, the film he made in Mexico, can't be counted as one of his films, because he had enormous difficulties with the backers of the project who prevented him from editing the film as he had intended, and even put on commercial release versions which had been cut and re-edited. He had so many difficulties, and that's what I could not have put up with in the cinema: having to spend so much time simply getting together all the material to begin creating something. You have to struggle so much over what you're doing, then try to find the money, compete for it … You know, one can easily imagine how the difficulties Eisenstein had to fight against all his life, and particularly at that time, in order to make his films, overcame him in the end and brought about his early death.

At least with painting you don't have to gather together anything

out of the ordinary in order to start work; just some paint, some brushes and a few canvases. Agreed, that all costs money, but I think it's something you can manage even when you're young, when you're beginning and have no money at all.

MA But to come back to what we were saying: cinema, for you, is not like photography. It isn't simply a useful tool, it also produces shocks and emotions?

FB Yes, but a photograph can also produce emotions. I don't really know. What do you think?

MA Sometimes I am affected by photographs, but certainly with cinema there's movement and also the changing viewpoints, sound and colour, there are so many things … the language of cinema, can be so full. Perhaps it arouses emotions more easily? Cinema audiences used to cry and laugh out loud. The cinemas themselves were incredibly lively. The

success of Chaplin, for example, can be explained by the public's incredible sympathy for him. There was a sort of osmosis between him and his audience.

FB Yes, but that was true in the early days. I get the impression that the cinema has not turned out as one might have expected, that it has fantastic potential that hasn't been exploited.

MA Apart from Eisenstein, are there any other film makers that you respect?

FB Well, he really was a great director. Buñuel too, of course. There are some very powerful images in Buñuel's work. And also Resnais. But he hasn't had such an affect on me. I like him but his work hasn't influenced me. Then there is Godard; I like some of his films. He's a very original film maker and, at the same time, one feels that he has seen a lot, has thought a lot about cinema. He's both spontaneous and cerebral. With

Resnais and Godard, some remarkable things were beginning to be done in France but, as I was saying, I feel that things have not continued to advance, that cinema has remained at a very primitive stage. I don't really know if these images have had any influence on me. Besides, you never know what effect an image has on you. Images enter your brain, and then you just don't know how they are assimilated or absorbed. They're transformed, but you don't know exactly how.

MA You were talking just now about the relationship between the cinema and money, and you were saying that you wouldn't have been able to be a film maker because of the financial side of the profession, and the tensions that these financial dealings created for the film makers.

FB Yes, that's right.

MA What do you think of the place that money occupies today in the

world of art? Do you think that the market directs creativity? Is there some comparison here with the practices of the great cinema producers in the golden age of Hollywood, who imposed considerable constraints on the film makers, interfered with the final editing of films, and played a defini- tive role in the creation of the work of art, all in the name of public taste?

FB No, I don't think there is. The problem is more a question of the help you need when you begin to paint. When I was young it wasn't the dealers who helped me. I had friends who encouraged me. When you're young, you can always find people who are interested in you and in what you're doing. At that time of life, everything is different. But it's obvious that in most cases, when a young person launches himself in his career, he has no money, and that, he will find, can cause him problems. I have always managed to get by, but I was quite ready to turn my hand to anything. I think that I'll always be able to manage. For those who are starting out, getting enough money to be able to work can pose real problems.

MA But tell me, how have you personally managed for money since adolescence? I believe you did a whole range of mundane jobs before totally devoting yourself to painting?

FB Yes, I did. My parents were totally against my becoming a painter. My father, with whom I didn't get on very well, didn't want to help me. He didn't want anything to do with it, and there was no question of his supporting me. At that time, in Ireland, parents were under no obligation to help their children financially. There was no Child Allowance. When I turned sixteen, however, my mother began to pay me an allowance of £3 a week. At that time, you know, you could live on £3. I didn't know then that I would devote myself to painting. That came later. I left first for London, then Berlin. I spent some time in Paris, and then I returned to London where I did many different jobs.

MA You were a decorator?

FB Yes, but I hated it. In a certain way, decorating is the opposite of painting, its antithesis. I also loathe painting that tends towards decoration.

MA You have tried other professions, haven't you?

FB Yes, I've also been a cook.

MA A cook?

FB Yes, I was a good cook …

MA You were doing jobs that had nothing to do with painting. Did you paint at all then?

FB It was after staying in Paris, where I saw an exhibition of Picasso, that I said to myself that I was going to paint. But these jobs were very

frustrating. Luckily, after a while I met people who helped me.

MA Who were these people?

FB At the end of the twenties, I got to know a man who lived in Chelsea with his wife and their two children. One day he came to see me. He had become very interested in my painting and, from that moment, he began to help me. He never let me down.

MA And he helped you for a long time, did he?

FB Oh yes, for nearly fifteen years. He gave me money. He had a fortune.

MA If I understand rightly, thinking back to what we were saying just now, this was someone who helped you, but didn't try to interfere in your work, leaving you free to do as you thought best?

FB Yes, he had great confidence in me and, at the same time, he followed very attentively what I was doing; deep down I think he influenced me in many areas. He has certainly been very important to me. It was he who, later on, gave the three figures of the *Crucifixion* to the Tate Gallery. At first they didn't want them. He had to insist before they finally accepted them.

MA What was his name?

FB Eric Hall.

MA So you soon had people to buy pictures from you, and you were able to begin making a living from your work?

FB No, it didn't happen quite like that. How did I begin to sell pictures? Here in London I knew a painter, who is dead now, whose name was Graham Sutherland. He was very successful. He became interested in

what I was doing and spoke about me to Erika Brausen, who had the Hanover Gallery. She came to see me and immediately bought a large canvas I had done, which is now in the Museum of Modern Art in New York. That's how it began. I'm fairly sure that's the first picture I sold. But of course before that, all those years up till then, there had been Eric Hall who really did help me considerably.

MA Since you mention your first sale to a gallery, tell me about your relations with dealers. After the Hanover Gallery, the Marlborough immediately held an exhibition of your work?

FB No, that came a few years later. Erika Brausen didn't have any money of her own, so she had to get financial backing to run the gallery. Soon after I met her, she found an American investor for her gallery, who didn't like my painting. Later she found someone else who didn't like what I was doing either. Well, she continued to give me money so that I could paint and buy canvases, but there came a time when that was no

longer possible, because of the problems with the people who didn't **27**
like my work, and that's when the Marlborough Gallery contacted me.
They paid my debts and that was that.

MA So in your case, your first dealer was forced to part with you,
because of her investors. Difficulties with financiers affected your dealer
first, then you later. But you more indirectly. It isn't exactly the same as
the case of Eisenstein, but in the end isn't the result rather the same?

FB No, not exactly. As I said, I always found a way to get by.

MA And what does money mean to you today?

FB I'm very happy to have some. I never imagined making money from
my painting when I began. I've been lucky in that people like my pictures
and buy them, without my really understanding why.

MA Is the art market something that you dislike?

FB No, not particularly.

MA And what about the incredible price your pictures fetch?

FB I have no particular reaction to that. It's the work of the dealers. They buy my pictures from me and then it's up to them. I have some money, but the prices that you see at the sales aren't the sums that I receive. I am rich, but not as rich as you might think from the prices my pictures fetch. That's how it is; that's how the system works.

MA And you dislike it?

FB No, not really.

MA But dealers have played an important role in the history of painting.

In France, for example, there have been some great dealers: Durand-
Ruel, Vollard, Kahnweiler. Have there been dealers of the same standing
in England? Have you ever met any?

FB No, unfortunately dealers didn't have faith in me until I had made
money, not before, but perhaps that was just a sign of the times.

MA In what way?

FB Perhaps it was easier to be a dealer before. I don't know.

MA You just said that you didn't know why people began to buy your
work. What does people's interest in your work mean to you? Does it
matter to you or not?

FB The way people regard my work is not my problem, it's their
problem. I don't paint for others, I paint for myself.

MA Are you aware of the great enthusiasm you have generated all over the world, amongst young and old alike?

FB No, not really. I have certainly been lucky. It's just chance if what I do interests people. Of course I'm very happy that it does. But I don't think you can ever know what's going to interest people; I can't predict it myself. I certainly don't bear that in mind when I'm working. What's more, you have to wait a long time to know whether an artist will be recognized or not, sometimes fifty or a hundred years after the artist's death. During the artist's lifetime, any interest shown in him or her may be just a passing phenomenon, a fashion.

MA But you're aware of the influence that you've had, and still have, on other artists? People like Velickovic and Rebeyrolle seem to me to have been directly influenced by your work.

FB I knew Velickovic. He once asked me to buy a Muybridge for him in

London because he had lost the one he had, and couldn't find one in Paris. I got one for him. He's a charming man, but I don't think I've influenced him. Perhaps a little, but his work is inspired more by Muybridge's photographs. In his work, or at least in those works that I've seen, but I haven't seen any for a long time, there were men or women walking or something similar; I haven't done anything like that.

MA And Rebeyrolle?

FB No, I don't think so. No, frankly, I've never believed that I had influence. To tell you the truth, I've never even thought about it.

MA You do accept though, that a young painter today might model himself on you?

FB Yes, I do, but that's normal. It's always been like that. The young are influenced by their elders or by their predecessors. At a certain time in

my life I was very much influenced by Picasso. Perhaps 'influence' isn't quite the right word, I certainly don't think Picasso would have used it. Let's say perhaps that Picasso helped me to see … No, not to see, it isn't even that … Whatever it is, I admired Picasso greatly. For me, he was the genius of the century. Everything of his that I saw at that time had a huge effect on me. It changed me a lot. It was, as I told you, seeing an exhibition of his work at Rosenburg's that made me decide to begin to try and paint. Some of the things that I did then were very much influenced by him. Later on, I don't know. I think I've been influenced by everything I've seen. But it's true that Picasso was also influenced by everything. He was like a sponge that soaks up everything. That's what I am thinking of when I talk about influence; something like this phenomenon of a sponge that absorbs everything.

MA Since we're talking about influences, which are the painters that influenced the young Francis Bacon? Picasso above all, I presume?

FB Yes. I saw that exhibition at the end of the twenties. It might not have been the best exhibition, but it had a huge effect on me. I believe that Picasso had a great gift as a draughtsman, and more than anything it was his capacity always to do something new that was so extraordinary. There are many of his works that I don't like, nine-tenths of what he did, but he produced remarkable works at all periods of his life, and came up with something quite new each time. That is what's extraordinary. With such a vast output, one can't like everything anyway. For example, what he did from Velázquez's *Las Meninas*, I don't like at all. I don't think it worked. But variations on a theme aren't that straightforward. I remember having a discussion with Giacometti on this subject. He asked me, 'But why all these variations?' I don't think he was really against the principle; in raising the question he simply wanted to explore the matter. In fact, some of Picasso's variations have been of interest, though what he did from Manet's *Déjeuner sur l'herbe*, like the *Meninas*, I don't really think was successful.

I know someone who lives near here, who bought a lot of Picasso's

works from his last years. I don't find them very interesting. I agree they are perhaps remarkable for a man of his age, but I don't think there's anything much to be gained from these works, at least not for me. The best work from that period is perhaps *La Pisseuse*, but there are lots of other works that border on caricature. I accept that there's often an element of caricature in great art, but for me, generally, the last works of Picasso go too far. I don't like most of the works from the Cubist period either: I find them too decorative, they do absolutely nothing for me. They are variations again, a mixture based on the work of Cézanne and discoveries from African art. It's not a period I like.

MA And *Guernica*?

FB I don't like *Guernica* either. People have gone crazy over that work. Of course the work is of considerable importance as an historical event, but I don't think it's one of Picasso's best works. I don't know really; at any rate, it doesn't affect me. I think that his best works come from between

1926 and 1932. That's the period when he painted figures on beaches at Juan-les-Pins and at other places in the north of France. He has invented some very interesting images in these pictures. It is said to be the period during which he was influenced by Surrealism, but he wasn't a Surrealist. He was Spanish. Perhaps in a way the Spanish are always Surrealists? I don't know. For me, Picasso's greatest period is at just that time. It's also the period when he carried out a series of works inspired by meeting Marie-Thérèse Walter. I remember seeing a drawing from those years which belonged to Penrose and which was quite astounding. That said, Picasso was such a good painter that there are extraordinary things from all periods of his life.

MA And apart from Picasso, who else has influenced you?

FB I've probably been influenced by everything that I've seen.

MA Well then, to put my question differently, which are the painters,

past or present, that you particularly like?

FB I think I would have to mention Velázquez …

MA The question was in the plural.

FB Some others … I like the primitives.

MA The Italian primitives?

FB Yes, but not only them; primitives in general. Amongst the Italians, I am thinking of Cimabue. I saw his *Crucifixion* in Florence before it was destroyed. It was one of the most marvellous Crucifixions that I have ever seen. When Florence was flooded, it was terribly damaged. You could see the skeleton of what remained and it was still quite remarkable. Perhaps the memory of how it had looked before the flood had stuck in my mind, and that's why I found what remained marvellous.

That's possible. I'm thinking of Cimabue, but there are certainly plenty of other painters amongst the primitives.

MA And in the Renaissance?

FB Here in England, it's strange that we've had many poets, great poets, even if they weren't of the stature of Shakespeare, but we haven't had any painters like Raphael or Michelangelo. I like certain works by Michelangelo enormously, especially the drawings with their grandeur of form and grandeur of image. But I don't like all the works of the Renaissance; far from it. I don't like the famous paintings like da Vinci's *Mona Lisa* at all. I find that they're often boring works from which you get nothing. I find it hard to understand Duchamp's joke with the *Mona Lisa*. For me it's simply boring, and it's even more boring because it's so famous.

MA And the German and Flemish painters, Holbein, Bruegel?

FB They mean nothing to me.

MA Do you feel that you're closer to Bosch?

FB Oh no, not at all. Everyone seems to think that I must like Hierony-mous Bosch. I don't know if my pictures make people think of his, but I can certainly assure you that his work does nothing for me at all.

MA What about later?

FB Later? Rembrandt certainly. The self-portraits from the end of his life are superb. He had done others earlier, but the later works are even more beautiful. The way in which it's always Rembrandt that you see, in an image which changes each time, is really astonishing, magnificent.

MA And from the same period, Vermeer, Poussin?

FB Everybody likes Vermeer, except me. He doesn't mean anything to me, he has no significance. In Paris, about twenty years ago I think, I saw the exhibition which was held at the Jeu de Paume, that people were mad about. It was an exhibition that left me completely cold. As for Poussin, I recognize his great qualities, particularly his extraordinary sense of composition, but everything in his work has a bit too much mathematical precision, something which I must admit doesn't mean a great deal to me as far as painting is concerned.

MA And in the eighteenth and nineteenth centuries?

FB Where? In what country? Here in England?

MA Not just in England, but yes, here too. Do you like Turner?

FB I think he's a remarkable painter, but generally I don't like land-scapes. It's a genre that doesn't interest me much. I hardly ever look at

them. Here and there perhaps, some Constable sketches, but what I was saying just now about the Renaissance is also all true for this period: England was not at that time a country of painters; rather it was a country of poets and writers, and I believe that's still true today. It's not the same in your country; in France you had some very great painters in the nineteenth century.

MA So who exactly among the French painters, or the painters who worked in France in the nineteenth century, do you particularly like?

FB I'm very fond of certain portraits by Ingres and I also like *The Turkish Bath*, but I don't see any value at all in history painting. Perhaps I haven't seen enough of it, but those paintings I have seen have never moved me. Apart from Ingres, there were so many painters, and great ones, in France in the nineteenth century that it's difficult to answer your question.

MA I believe you've been to see the Géricault exhibition which is on at

the moment at the Grand Palais in Paris. Do you like Géricault?

FB Yes. The impressive thing about Géricault is the sense of movement in everything. Especially the representation of the human body and of horses; everything is captured in an incredible sense of movement. But when I talk about movement, I don't mean the representation of speed, that's not what it's about at all. Géricault somehow had movement pinned to the body. He was fascinated by it.

MA Why?

FB Amongst the Impressionists there are some works that I like enormously. There were some very remarkable painters amongst them: Manet, Monet …

MA Van Gogh? Cézanne?

FB Oh yes, but Cézanne wasn't an Impressionist and neither, in a certain sense, was Van Gogh. His way of treating the material is quite different from the technique of the Impressionists. You know, his use of that very thick paint, that very thick material. His manner was unique. He is one of the great geniuses of painting. For me, Van Gogh is the greatest. He really did find a new way of depicting reality, even for the simplest things, and that method wasn't realist, but was much more powerful than simple realism. It was really a work of re-creating reality. As for Cézanne, I only like certain of his works. I have to choose them very carefully. I'm not sure what place he really has in the history of painting. I can see that he has been important, but I must admit I'm not madly enthusiastic about him, as many people are. All things considered, I think that I only like the works from the end of his life. I find them much more interesting than those from earlier periods. It's the period when there is almost nothing on the canvas, when the subjects have almost completely disappeared, are hardly there any more, when one has the impression that they've barely been sketched and that they're about to disappear. I

like that period a lot; apart from those, I don't like Cézanne. But do you see? The surprising thing is, isn't it, that when you talk about the Impressionists, as soon as you think about all those painters, you can't help but notice how different they all were. Beware of definitions. No great painter can be reduced to a category. One can say such and such a painter is an Impressionist, others are Expressionists, and others are Cubists, but basically you're saying nothing at all; in saying that you're simply identifying a style that says nothing about the painting itself.

MA And Degas?

FB Ah yes. It's his pastels that I particularly like. They are extraordinary. Especially the interiors with women at their toilet, the nudes rather than the dancers. Generally speaking, his bodies of women are superb. He really is the only artist to have known how to handle pastels like that, with those lines between the colours.

MA You also went to see the Seurat exhibition in Paris last spring. Has Seurat been important to you?

FB I admire Seurat a lot. We have perhaps one of his best pictures here in London, *Bathers at Asnières*, which I think is a magnificent work and which wasn't, by the way, in the exhibition at the Grand Palais. But above all I like his sketches. I think though that his last works were less interesting because he tried too hard to explain things and to apply his theories. I think that his ideas about colour and composition or about other subjects, his ideas in general, blocked his creativity. His explanations on how to paint seem to me, at the end of his life, to have killed his instinct. But he did die very young and it's impossible to know what he might have done later, had he lived.

MA What about more recently? Amongst contemporaries, which painters or trends in painting are most important to you?

FB That's a difficult question. I don't quite know how to reply. After Picasso, I don't really know. There's an exhibition of pop art at the Royal Academy at the moment. I went telling myself, 'There might be something that can help me. I will get something out of it, or perhaps it'll give me a shock.' But when you see all those pictures collected together, you don't see anything. I find that there's nothing in it, it's empty, completely empty. There's Warhol, of course, and he is better – he's even the best compared to all the others; but all the others are truly bad.

MA Well then, what do you think of Warhol?

FB I can't deny that Warhol has a certain importance, even if he isn't important to me. He occupies, at any rate, a place in the history of contemporary art, even if he didn't realize that he went off course and didn't understand fully where his strengths lay.

MA Did you know him?

FB I can't really say that I knew him, but I did meet him in New York at the home of Princess Radziwill. He took me to The Factory. He was a very intelligent person. I think that even if his films don't mean anything to me, they are interesting and are part of the best work he's done. Though those which Paul Morrissey has made are probably better. *Flesh*, for example. Have you seen it?

MA Yes, *Flesh* was interesting.

FB Yes, it was, wasn't it, but in fact it was based on ideas from Warhol. I've also seen another thing by Warhol, I don't remember the title any more. It lasted six or eight hours I think, that's all I recollect, I only saw a part of it. He had left the camera running, but I must say that it produced nothing of interest at all.

MA Perhaps it appears very dated today? Perhaps it went out of fashion

very quickly? It seemed very fashionable at one time, then all of a
sudden very out-of-date.

FB Yes, it's like society gossip, nothing much lasts, it passes very quickly. I found this exhibition at the Academy very sad in the end, very depressing. It's a shame, because Warhol has done some very interesting things: for example, *The Electric Chair* or his series of variations of colours on a single theme. *The Car Accidents* too, that wasn't bad but it wasn't as good, because it was verging on realism in the end. Generally speaking, Warhol had good subjects, he knew how to choose them very well; but his problem, basically, was that what he was doing was realism, simple realism, and in the end it didn't lead to anything very interesting.

MA You have, however, painted the same subject as him at least once: a portrait of Mick Jagger.

FB Oh, but that was really a commission. Someone had asked me to do the portrait, but I didn't know Jagger and I wasn't thinking of Warhol at all when I was doing the picture.

No, you know, even if he had been the most intelligent of pop artists, intelligence has never made art, never made a painting … unfortunately.

MA What does make a painting?

FB No one really knows.

MA But if it isn't simply a question of intelligence, where does painting come from? From the heart, from the stomach, from the intestines?

FB Who knows where it comes from?

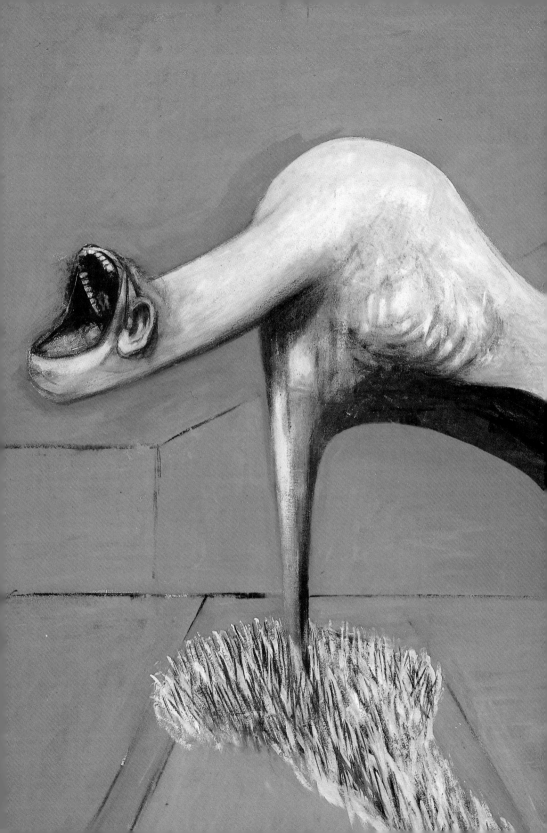

4. *Three Studies for Figures at the Base of a Crucifixion*, 1944 (detail of right-hand panel on previous page)

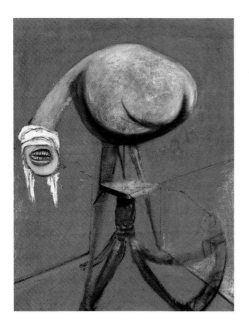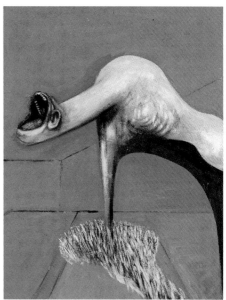

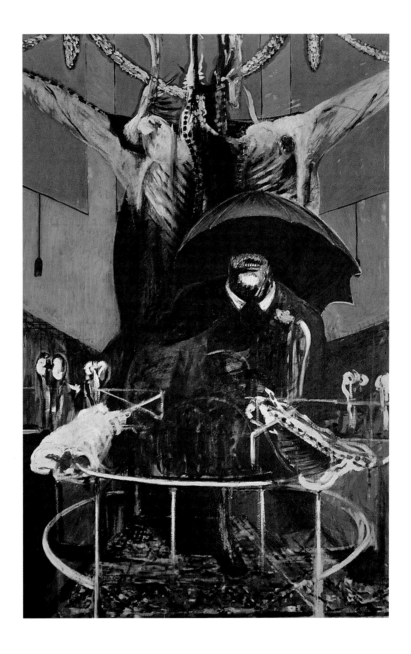

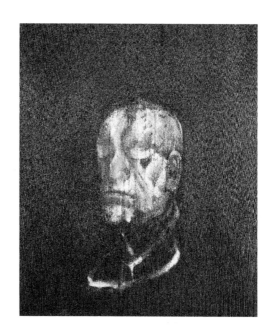

5. **Painting**, 1946 (left)

6. **Study for Portrait III (After the
Life Mask of William Blake)**, 1955
(above)

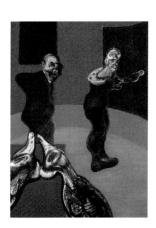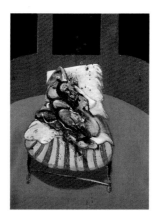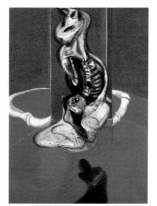

7. ***Three Studies for a Crucifixion***,
1962 (detail of central panel opposite)

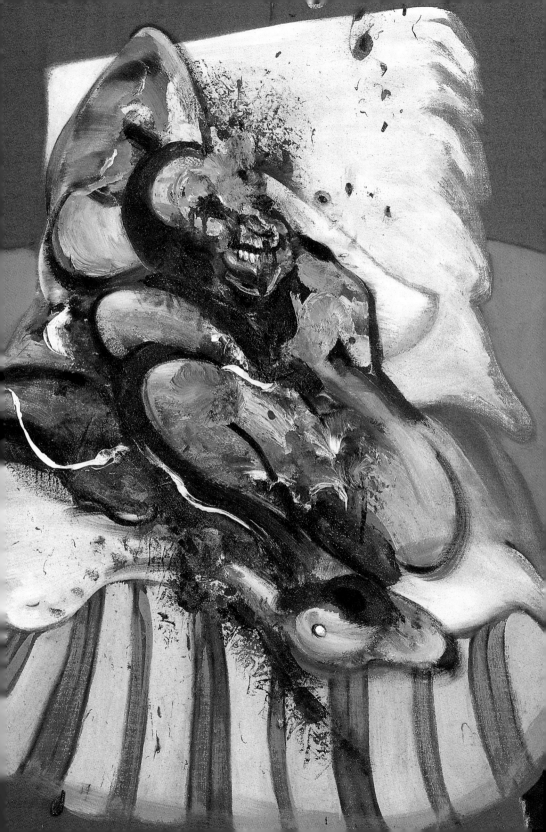

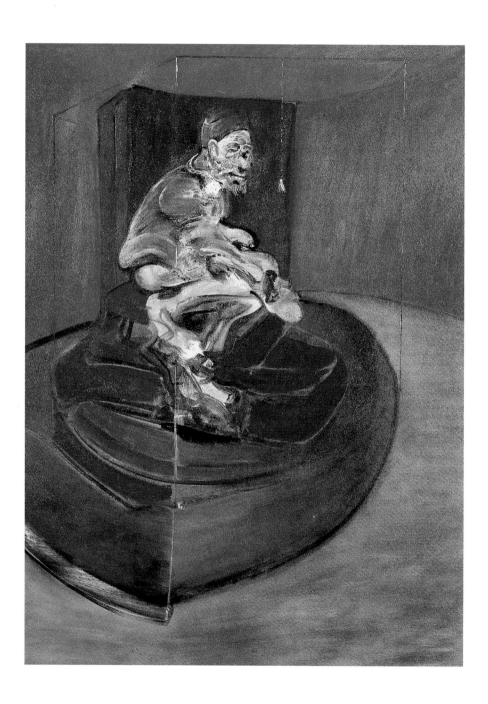

Francis Bacon illustrations

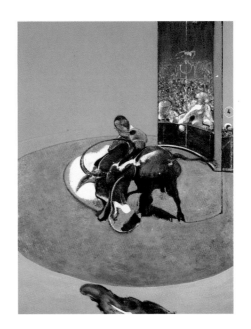

8. *Study from Innocent X*, 1962
(left)

9. *Study for Bullfight No. 1*, 1969
(above)

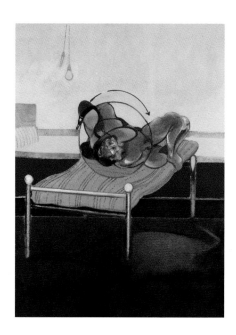

10. *Three Studies for Figures on Beds*, 1972

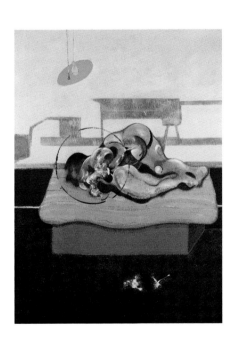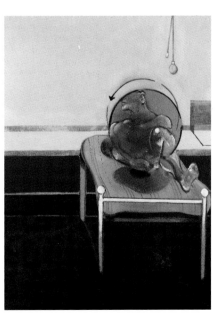

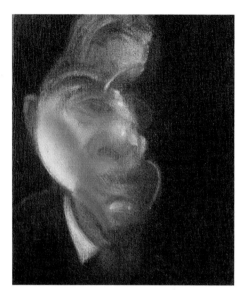 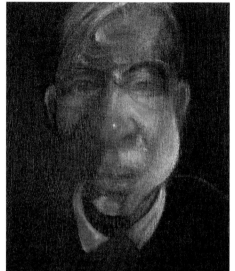

11. *Three Studies for Self-portrait*,
1979

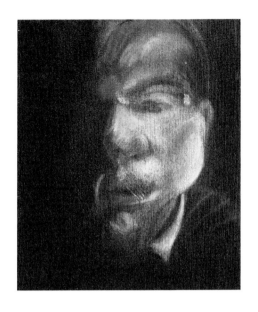

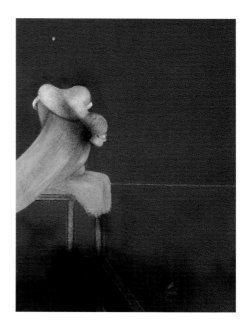

12. *Second Version of Triptych
1944*, 1988 (detail of central panel
overleaf)

Francis Bacon illustrations

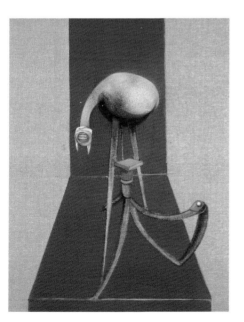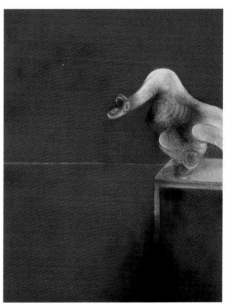

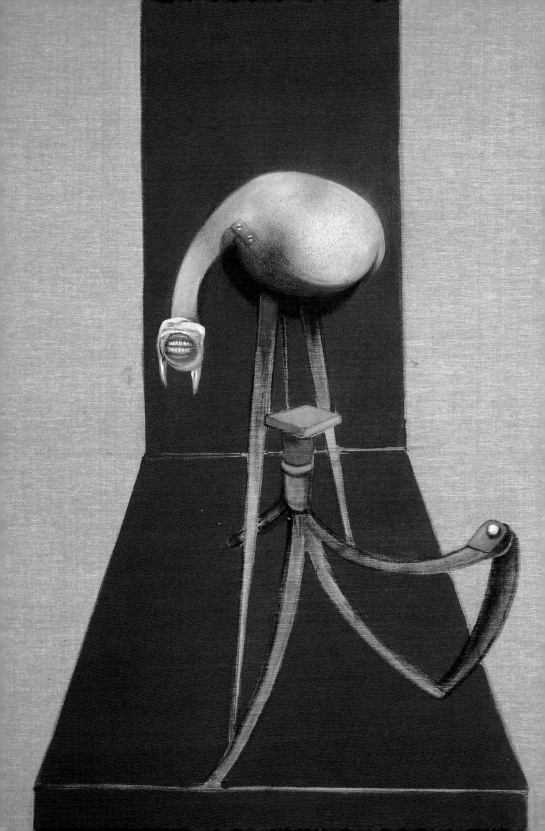

second conversation

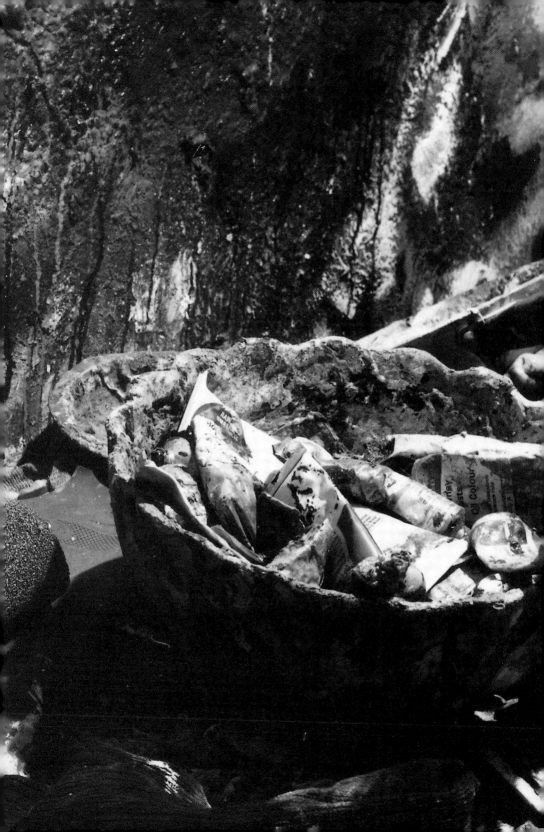

MA Francis Bacon, last time we were talking about contemporary painters. You have, I think, met Balthus. Is his pictorial world quite alien to you or are there some things in his work which appeal to you?

FB There are some aspects of his work that I admire, but I do think that we're very far apart from each other. I like his landscapes; there are two or three in particular that I like very much. But I prefer the work he did a long time ago, when he was in Paris before the war, a picture entitled *La Rue*, of which there are two versions, I think. I seem to remember that in one version the street is more crowded with people than in the other, and the treatment of the two works is very different: everything is more precise, more distinct in the second. I like both of them. I had some friends who knew Balthus well, but it was through another friend, Isabelle Rawsthorne, who still lives near here and who was a close friend of his, that I met him.

MA You and Balthus also had another friend in common, Alberto

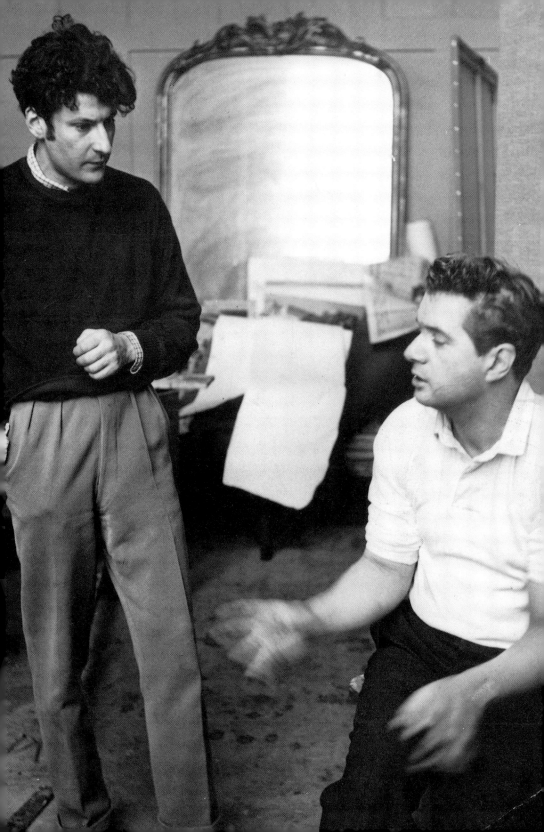

Giacometti, the subject of a big retrospective at the City of Paris museum at the moment. What's your view of Giacometti?

FB I knew Giacometti. I met him when he came to London for an exhibition of his work at the Tate Gallery. He was accompanied by his wife, Annette, as well as by Michel and Louise Leiris. He stayed at a hotel not far from here, and I remember that we spent a whole night talking to each another. At that time I had a friend who came from the East End. He was an astonishing looking person, and Giacometti was adamant that he should come to Paris to have his portrait painted. I encouraged my friend to go, but in the end it didn't happen. It was the language barrier; Giacometti not speaking a word of English, and my friend not a word of French. I urged this friend partly because I have always loved Giacometti's portraits, particularly those done in pencil or charcoal. I know he once said that the most exciting thing for him was to see some unknown quality materialize every day on the same face. I know exactly what he meant, and I've always thought that his portraits were very interesting.

Of everything that he's done, I much prefer his drawings to his sculpture.
He is much better known for his sculptures; they've been reproduced so
much throughout the world. It's thanks to them that Giacometti is so well
known today. I think people have failed to appreciate his drawings for a
long time and, in my opinion, they're the strongest things he's done. I do
like some of his sculptures, but certainly not those from the Surrealist
period, nor the famous works such as *The Nose* or *The Hand* which don't
work. I think there are some sculptures by Picasso which are much more
important than many of Giacometti's sculptures, but I definitely prefer
his drawings.

MA Yesterday, when we were leaving the restaurant, we bumped into
Lucian Freud. I know you were once good friends. The French public
only really discovered him through a fine exhibition at the Beaubourg in
1987. Is he one of the contemporary painters that you like?

FB Yes, I like his portraits especially; well, some of his portraits. We

were good friends, but we don't see each other any more. It's rather sad, but that's how it is. We're not as close as we used to be.

Incidentally, about that exhibition in Paris, there was a portrait of me in it painted by Freud. It was a small picture. Well, during another of his exhibitions, the one in Germany, someone stole it.

MA Then someone has a portrait of you at home! That's the consequence of fame in a way …

FB Yes, if you like, but the fame of which person? … One doesn't know.

MA Apart from Freud, are there other contemporary painters, in England or elsewhere, that interest you?

FB There are some interesting painters here in England at the moment, but after so many decades of very great painters, if one thinks of the Impressionists and of Picasso, perhaps it's only normal that one should

find that everything seems to be rather lacking in strength and origi-
nality. After any great period in all the arts, I think you find a period of
repose, of hibernation almost. It's true that I don't admire anyone at
present. I find the young are not very talented and that there's nothing
really exciting happening anywhere in the world, either in France or the
United States; but perhaps it's just a temporary thing and it will pick up
later. Maybe it's just me because I haven't seen the talent of today or
because the state of my health has affected my ability to discover those
painters who are reviving the art of painting. I don't know.

MA But back to the question that I asked you last time: we don't know
what it is that makes a painting, but what is it that makes one paint?

FB The main problem is how to create with one's instinct something
that one sees. One hardly ever manages it. One is always close, I think.
But the main problem is managing to create something instinctively. As
for explaining instinct, that really is very complex. When you see how

painting changes over the centuries, you tend to ask yourself whether instinct itself doesn't change from century to century, if it isn't modified by everything that you see, everything that you hear. I don't know. Anyway, what I can say is that instinct asserts itself. The way in which you make an image, that you can perhaps explain, because it's a question of technique. Techniques change, and one could talk about painting by making a sort of history of the techniques of painting, but as for what it is that makes a painting, which is always the same thing, the subject of a painting, what painting is; you can't explain it – it's impossible. What I can perhaps say is that in my own way, in desperation, I go here and there following my instincts.

MA Do you reject any attempt to explain your work?

FB Explanation doesn't seem necessary to me, either of painting or of other artistic fields, such as poetry. I don't believe that it's possible to give an explanation of a poem or a painting. Picasso, for example, spoke

very well about painting. He said all sorts of intelligent things about it. But he never succeeded in explaining his own genius. It seems to me that explanations inevitably fall short. At any rate, I have no need of them myself, not even in the case of something that I don't understand at all. Take music, for example. That's something we've often talked about together. Well, I don't understand music, even though it affects me very much, and yet I have no need of explanations. I know that people often look for explanations; if they need them then it's always possible to find other people who can provide them, but that seems a bit odd to me.

MA But in saying that, do you realize that you are rejecting any critical approach?

FB It doesn't really interest me.

MA Even as a way of coming closer to a work?

FB Yes.

MA Don't you think that criticism can help provide an approach to a work, that it can have a didactic function and provide an introduction and, perhaps, even stimulate the creative process?

FB No, I don't think so. The only effective criticism is your own; that is what affects your work when you're in the process of painting, but that is not the same thing. The critical sense which comes into play there is the faculty of discovering what is possible, which way you can go, with everything that's already on the canvas, to bring about the best possible final image. But what seems best to me won't necessarily be most pleasing to those who will look at my painting later. I don't think that it's a question of explanation. What seems more interesting to me is the history of painting or of the arts in general – in order to understand what's made a certain painter, look at where he comes from, see who and what has inspired his work, see if he has managed to add

something, even if it's almost nothing, to the long chain of those who have practised the art in which he expresses himself – yes, to do that, it's perhaps useful to know a little about the history of painting or of music .

MA You mean that it's important to place the work of a particular artist?

FB Yes, that's it. I'm sure that every artist fits into a context, is influenced by his particular heritage and is placed at a certain point in time. Just as if he's using all his ingenuity to hit the same nail persistently, but that's another story. What is true, though, is that even if you manage to understand where artists are coming from, what makes one work fail and another work succeed remains a mystery. I don't even understand how certain works that we've already talked about so much, and about which so much has been written, have managed to hold out.

The most important thing is to look at the painting, to read the poetry or to listen to the music. Not in order to understand or to know it, but to feel something.

MA If I understand you correctly, with painting or with the other arts, the thing is to feel emotion?

FB I don't know if that's how to put it. It is probably something like that that you're after when you look at something or listen to something, whatever it is, even if you don't realize it. It's the old idea of classical Greek theatre: the public came to experience feelings of terror and thereby purge their passions. Of course, today things are different when one goes to see an exhibition or listen to a concert. If, though, in the presence of a work, someone experiences powerful emotion, then perhaps you could say that the artist has been successful; but it's not always the case. It's all very complicated because the artist might have done something that he wasn't happy with, but which, nevertheless, affects those who look at or listen to it. And the opposite is also equally true. I'm not sure that experiencing emotion is the most important thing as far as creativity is concerned. Perhaps it is for the person who experiences it, but probably not for the artist himself.

MA Coming back to the subject of music which you mentioned just now, I want to look again at the problem of explanation. At the beginning of 1991, you went to hear the original version of *Explosante Fixe* by Pierre Boulez, at IRCAM in Paris?

FB Yes, I did.

MA It so happened that at that performance, Pierre Boulez played his work in the raw state it was in at the time, and then commented at length on the genesis of his work. Did it surprise you, that an artist could explain what he was in the process of doing?

FB Yes it did, because I don't think I could ever do anything like that with my painting. Can one explain music? It's true that what Boulez explained that evening interested me very much. But to be honest, I had heard some of his works before, I had already read things written about him and by him, and I had understood that, with the help of new tech-

niques, he was trying to find a new way of recording his instincts. And that's what we were saying last time; the only persistent problem for the artist is to express a subject which is always the same and which cannot be changed, by finding a new form of expression each time.

MA So, what's more important than the emotion, the thing you experience, is what you call instinct. What do you think instinct is?

FB Instinct? I don't know. It's true that it certainly is the most important thing. If you manage to do something following your instinct as closely as possible, then you have succeeded; but that's truly exceptional, it very rarely happens.

MA In which of your works do you think you have achieved this?

FB Perhaps in the first version of *Painting* of 1946. I was doing a landscape and I wanted to make a field with a bird flying over it. I had put a

whole heap of reference marks on the canvas, then suddenly the forms that you see on that canvas began to appear; they imposed themselves on me. It wasn't what I set out to do. Far from it. It just happened like that, and I was quite surprised by what appeared. In that case, I think that instinct produced those forms. But that's not the same as inspiration. That has nothing to do with the muses or anything like that; no, it happened quite unexpectedly, like an accident. I set out to do one thing and then, in a completely astonishing way, something quite different happened. It's both accidental and at the same time completely obvious. That, to me, is instinct; but I cannot give you a definition, I can only tell you how those things happened one day, that's all.

MA You used the word 'accident'. It's a term you are fond of using. Can you tell me more precisely what you mean by it?

FB I don't really know how to define it. I don't think that you can explain what an accident is. It covers many different types of reality.

82 For example, when you're using oil paint, it can result in an effect that you cannot control. You can apply a blob of paint, turn the brush in one way or another, and that will produce a different effect each time which will change the whole meaning of the image. While you're working in a certain way, you try to go further in that direction, and that's when you destroy the image you had made; an image that you will never retrieve. That's also when something unexpected suddenly appears; it comes with no warning. One knows, one sees something that one's going to do, but painting is so fluid that one can't note anything down. What's most surprising is that this something which has appeared, almost in spite of oneself, is sometimes better than what you were in the process of doing. But it isn't always the case unfortunately! Sometimes, by going back to paintings and continuing to work on them, I have destroyed works which were much better at the beginning than they were when they were finished.

MA Do you mean to say that when you begin, you don't know which

direction you're going in and even less where you will end up?

FB No, it's not quite that, because when I begin a new canvas I have a certain idea of what I want to do, but while I'm painting, suddenly, out of the painting itself, in some way these forms and directions that I hadn't anticipated just appear. It is these that I call accidents.

MA Could you call them accidents of the unconscious?

FB Not exactly, because that word brings psychoanalysis too much to mind, and I don't think that accidents are quite the same thing; but perhaps, from a certain point of view, one isn't very far from what Freud meant.

MA Do you think that painting is brought about by accidents?

FB No, it's more complicated than that. What does finally appear on the

canvas, in the best cases, is probably a mixture between what the painter wanted and those accidents that we were talking about a moment ago. It seems to me that in painting, and perhaps also in the other arts, there's always an element of control and an element of surprise, and that distinction perhaps comes back to what psychoanalysis has defined as the conscious and the unconscious.

MA I've seen some works by Freud in your library. You refer to psychoanalysis. Is it important to you?

FB I like reading Freud very much because I like his way of explaining things but, at the same time, never having undergone therapy myself, I'm not sure what to think of psychoanalysis. Perhaps it could have helped me? I don't know.

MA Do you think you would have achieved what you have achieved in painting if you had undergone psychoanalysis?

FB Perhaps, I really don't know. I know some people who have been undergoing therapy for a long time. After nine years they hadn't really changed, but perhaps it would have been better if they had changed and perhaps that's why they began the therapy. Whatever the case, it wasn't a success. But that's not necessarily the case with all psychoanalysis, definitely not, because Freud certainly wanted to treat the people who came to see him. I don't know if he succeeded, but I get the impression that the problem is that many people confuse psychoanalysis with confession. They go to see their analyst rather as if they were going to see the keeper of their conscience, and analysis becomes rather like religion. It's a bit like going to church. You know, people love talking about themselves and their little problems. I can't say that I feel particularly drawn to that type of thing.

MA So why did you refer to psychoanalysis just now?

FB Ah, it wasn't me who referred to psychoanalysis, it was you; you

were talking about the unconscious. But as I told you, I really like the way Freud explains things and there are some very interesting ideas in psychoanalysis. The classic distinction today between the conscious and the unconscious is a useful one I think. It doesn't quite cover what I think about painting, but it has the advantage of not having to resort to a metaphysical explanation in order to talk about what cannot be explained in rational terms. The unknown is not relegated to the realm of the mystical or something similar. And that's very important to me because I loathe all explanations of that sort. It's what I was telling you; what I call accident has nothing to do with some kind of inspiration with which we have credited artists for so long. No, it's something which comes from the work itself and which suddenly appears out of the blue. In the end, painting is the result of the interaction of those accidents and the will of the artist or, if you prefer, the interaction of the unconscious and the conscious.

But you know, things seem clear enough when you talk about them, but that's not at all what it's like when you're at the canvas. There you

don't know where you are or where you're going or, above all, what's going to happen. You're in a fog.

MA A fog?

FB Yes, when I work I only have a vague idea, sometimes even no idea at all of what I want to do. In a way it's purely by chance that something happens on the canvas. Most of the time it has nothing to do with the original idea, if indeed I had one to start off with. In other respects, it's also true that I have a curious type of self-discipline which is probably an asset, because painting doesn't just consist of throwing paint at the canvas. I don't have a master plan when I begin a canvas, but there is acquired skill which, together with time and age, amounts to a certain ability. I'm definitely more conscious now of what I'm doing than when I was younger, which isn't necessarily very good, but that's how it is, and I think it's this mixture of enthusiasm and the unexpected that goes to make up my painting.

At the moment I would like to do a portrait of someone I know, but I haven't the faintest idea of how to go about it. That's always my problem. I always think that I won't know how to do it, then along comes that encounter between my work and the act of painting, the accidents of painting, and then the picture emerges. I'm hardly ever pleased with it, but sometimes, when there's a happy combination of accidents and will, it can be satisfying.

MA A sort of mysterious alchemy in a way?

FB No, it's more chemistry really; it's the natural phenomenon of substances mixing to give new substances. There's no mystery, if by mystery one means something which is out of this world. With painting everything happens before our very eyes. The artist's studio isn't the alchemist's study where he searches for the philosopher's stone – something which doesn't exist in our world – it would perhaps be more like the chemist's laboratory, which doesn't stop you imagining that

some unexpected phenomena might appear; quite the opposite, in
fact.

MA Still, you reject all concepts of metaphysics?

FB Yes, I do.

MA You've already mentioned our conversations on music. We've had the opportunity to talk about music together here in London and in Paris. It was after a long conversation on the subject that the idea came to me for this conversation. My first question about music is: how important is it to you in your life?

FB Music moves me very much but, to tell the truth, I don't think I understand it. To me, music is quite different from painting. There are many painters that I don't like, painters who don't move me, but whose quality I am quite capable of perceiving. Rubens, for example, is

undeniably a great painter, his technique is magnificent, and I understand perfectly his importance in the history of painting; but he arouses no emotion in me. Nevertheless, when I see one of his pictures, I'm not on alien territory. Although I'm not moved, I can understand it. With music things are much more difficult. I don't have the reference points that I have with painting and I often feel lost. Also, I'm quite happy to enjoy it or not, and that's it.

MA But that's perhaps the main objective: to allow oneself to be carried by the music, to enjoy it or not, as the case may be. It's just what you were saying a while ago about Greek tragedy and which is true for every form of artistic expression, whatever feeling one experiences. Music of any kind allows the individual to experience deep and intense emotions. I think that's definitely one of its most fundamental characteristics.

FB Yes, but I think that not being able to understand the music that I hear is a considerable obstacle and, for that reason, I need to know more

about the history of music, I need to establish some reference points. I
think that I do like to place musicians and their works. It's not a
systematic knowledge of the whole of music that I'm looking for; but
sometimes, when I'm listening to a piece, questions occur to me and
then, I suppose, I would like to know certain things, to have at least
some indication of the influences and the development of a certain
work, the formation of a certain musician and the importance of another.
Possibly because I think that if I understand it better, I will appreciate it
all the more, but it isn't necessarily the best approach. Perhaps what one
should do is read the history of music, I don't know. But take, for
example, Debussy, whose *Pelleas and Melisande* we're to hear next
month in Cardiff, conducted by Boulez, well, I've often wondered if he
was influenced by Wagner. That's one thing that I don't know and I often
wonder about.

MA Wagner did play a considerable role in his development. Debussy
used to say, 'I am a Wagnerian to the point of indecency.' But he always

kept his distance from the worship which surrounded Wagner, and he was influenced whilst still retaining his own unique musical language. All his friends – musicians and poets – revered Wagner, but Debussy, despite his debt to Wagner, particularly regarding orchestration, knew how to exercise his critical judgement and preserve his originality.

FB I'm intrigued by Wagner's influence. You see, it's this type of question that interests me. What influence has Wagner had, and on which musicians?

MA One could write a book on that question, because Wagner's influence has been considerable. Either directly, for musicians such as Anton Bruckner, at least early on, or Richard Strauss, who composed in the Wagnerian tradition; or indirectly by breaking away, as in the case of Debussy or Schönberg. One can even see his negative influence, if I can call it that, on musicians who, from the beginning of their careers, turned their backs more or less determinedly on his aesthetics. I'm thinking

above all of a substantial part of French music, from the end of the nineteenth and beginning of the twentieth centuries, from Saint-Saëns to Satie, including Massenet and Fauré.

In addition, I should emphasize that his influence on musicians has been more perceptible in the writing of harmony than in the creation of musical dramas like *The Ring*. Since we're discussing it, do you enjoy opera? Do you ever go?

FB Yes, from time to time, but more because someone invites me or because I want to accompany someone who wants to go to a performance. Otherwise, I don't think that I would go of my own accord.

MA Have you ever been to a Wagner opera?

FB Yes, here I've been taken several times to the Opera House. I was very impressed by a production of *Lohengrin*. Some parts moved me very much, but I wouldn't know how to explain why. You know, listening

94

to music isn't at all the same thing for me as going to the cinema or seeing an exhibition. I have much more trouble with music, because music only rarely, if ever, reaches out to me. I'm much more susceptible to something visual; I react much more in front of an image than when listening to sounds.

MA From what you told me, you've also been to hear Schönberg's *Moses and Aaron*?

FB Yes, I have, but I don't think that I understood much of it. Is that a work that you could say is derived from Wagner?

MA No, the notation of *Moses and Aaron* is twelve tone. It's a work which was composed between 1930 and 1932, by which time Schönberg had been using this language for several years. It's in his early compositions that the structure is still very Wagnerian. Wagner did have considerable significance for him, as did Brahms. But he's a musician

who developed in an astonishing way; he has written some extra-ordinary works in many different languages, works such as *Verklärte Nacht* from his early period, *Pierrot Lunaire* in atonal language and *Moses and Aaron* from his late period. In music, Schönberg is similar to what you were saying about Picasso in painting: he was an artist who succeeded in creating remarkable works at different periods in his life, and in very different languages.

FB Ah yes, I see.

MA But to come back to opera, have you thought of designing sets for a production; has anyone ever asked you?

FB No, I've never really thought about it. But in the theatre, quite a long time ago, Peter Brook did ask me to do the set for *The Balcony* by Jean Genet, which he was putting on. I tried, but I didn't do it in the end and anyway I realized very quickly that I couldn't work in the theatre.

MA Why not?

FB Because the theatre is quite a different thing from painting. When I go to a performance, whether it's a ballet, a play or an opera, I don't look at the scenery. I don't know why, but to me it has nothing to do with what I'm seeing or hearing. Basically, the set is decoration, and you know what I think of decoration; it really doesn't interest me.

MA I'd like to ask two more questions about music. First of all, do you listen to records or cassettes, and if so, what type of music do you like? And secondly, what music would you like to hear as the sound track to a film about your work and yourself?

FB I do listen to cassettes from time to time, and I love listening to Maria Callas. As for your second question, I really don't know what to reply. I'd prefer to hand it back to you. What would you choose?

MA Well, without really having thought about it, I think I would like either Berg or Webern, or a jazz musician like Michel Portal?

FB Yes, perhaps, let's say then that I would trust you.

MA I come now to a question which is in a way the reason for our meeting some years ago now. You know that I'm interested in an area relatively unexplored until now, that of the connections between music and painting. Whether it's Pierre Boulez embarking on some very searching analyses of the work of Kandinsky or devoting, more recently, a long study to Paul Klee; or Olivier Messiaen finding connections between complexes of sounds and colours – to give just two examples of contemporary musicians who have investigated the interactions between music and painting, and whom we've already had the opportunity to talk about. Do you think that on the one hand one could envisage some convergence between music and painting; and can you imagine, on the other hand, that a painter, bearing in mind the examples that I

have given, could be influenced in some way by music?

FB It's very difficult for me to answer questions like that because I feel that I don't understand music sufficiently to be able to say pertinent things about a possible connection between painting and music. For example, I'm very surprised at the interest that Pierre Boulez shows in Paul Klee, but that's essentially because there's something in me which prevents me from appreciating Klee's work. I know that many people who are really well informed about painting like Paul Klee enormously, but he means nothing to me at all. I find nothing appealing about him. For me there's no depth in his pictures; I'm even tempted to say there is nothing to them at all. But I'm ready to admit that it's me who doesn't know how to appreciate his qualities, seeing that a huge number of people are passionately fond of his work. That said, it might be because I haven't seen enough of his work and that I've seen more reproductions than original works; that might be why I don't like Klee. It intrigues and interests me that someone like Boulez could devote a book to his work.

But you know, I would have great difficulty in replying to your question about painting and music, taking the example of Klee. I know that he was a musician too, and that there are often references to music in the sometimes humorous titles of his works. I have thought, in connection with that, that perhaps it was this amusing side of his work that attracted people, but not knowing it well, I can't see the link between music and painting in his work.

MA Music has had an influence on Klee's creation at several levels. First of all, he had musical parents and he was very young when he began to study the violin. He often depicted musicians, singers and musical forms, and he also strove to find graphic equivalents to music. It's a theme which he worked on with his students at the Bauhaus. He also made a graphic transcription of a score by Johann Sebastian Bach at that time. It's clear that in one way or another, music always accompanied Klee's life, creativity and reflections. He is, though, only one among several examples of creative people whose works show the influence of another art form.

100

FB Yes, but I think that these influences between music and painting are superficial. I think they represent two modes of expression which have nothing to do with each other, and that each artist in his field is confronted by very different problems. It is possible that for a musician or a painter, a picture or a piece of music might arouse emotions from which each of them may derive an extra stimulus to create in their own field; but I tend to believe that it's more likely to act as a simple trigger. I've been thinking about it ever since you first talked to me about these interactions, and I believe they only exist in this way. There are perhaps some painters, like Klee for example, for whom music will have been very important and others, of which I am one, for whom it's mainly what they see, and indeed everything that they see, which is the determining factor. But really, I think that each works in his own field, and that the fundamental influences come from the field in which one expresses oneself. I can imagine that by hearing a piece of music a painter may find extra energy to create, and that the reverse may also be true, that by seeing a painting a musician may have more enthusiasm to compose. I

have experienced this phenomenon of stimulation myself, not with music, but with photographs of the works of other artists. We've already talked about it with regard to Picasso, for example, but I really don't believe in the existence of more significant interactions. As a trigger, yes, although really, for my part, I don't quite understand how that can happen with music, given my difficulty in understanding it. I am willing to recognize that stimulation, but to transcribe the language of painting into the language of music or vice versa, to me seems quite impossible. It's something which, in my opinion, is totally unreal; they are two such different fields. The musical process is much more logical than that of painting, isn't it? No, really, I don't see a correlation.

MA In your opinion, then, this comparison between music and painting is problematic; you don't believe in a merging of the arts?

FB I don't know, it's perhaps possible in opera, but I don't think so.

MA Nevertheless, you would agree that this idea of interaction between the arts might have been productive, that at certain times there has existed some interaction between literature and painting, or between music and literature? Among many other things, I'm thinking of the famous sonnet by Rimbaud on the vowels and their colour equivalents or, indeed, the setting to music of numerous texts either as individual songs or as opera.

FB Ah, yes, but it's not the same thing. There has been an interaction between painters and writers: with painters illustrating the great works of literature; and writers, from Baudelaire to Leiris, devoting admirable texts to painting. To take the first example, an enormous number of works have been created, from the illuminated manuscripts of the Middle Ages to the illustrated works of the nineteenth and twentieth centuries, or to the prints which accompany limited editions or first editions, some of which are quite remarkable. It's a very widespread practice, but it has never appealed to me. I have been stimulated by

reading great literary texts, like Greek tragedies, particularly Aeschylus,
or Shakespeare, but not directly influenced.

MA What do you mean?

FB Well, I think one can be inspired to create something by everything
and anything from an advertisement to a Greek tragedy. What the great
writers have produced is a sort of stimulation in itself. Reading them can
make me want to produce something myself; it's a sort of excitement,
perhaps even like sexual excitement, like something very strong anyway,
a sort of very powerful urge, but with me that doesn't take the form of
attempting to illustrate texts in some way. I know that many people like
to get involved in that kind of thing, but not me. In my eyes, the genre
has at least two major defects: firstly, the fact that this kind of work tends
towards illustration, as I was saying to you a moment ago, and today
with photography, film and video there are much more viable and satis-
fying ways of rendering reality. Painting has nothing to do with

illustration, it is in a way its opposite, rather as decoration is also quite the opposite of painting. And secondly, it is the fact that one resorts to the techniques of printmaking, such as engraving or lithography, or other processes, all techniques that I totally and fundamentally dislike. Engraving isn't as bad, but the lack of substance and depth in lithography has always bothered me. As for links between music and literature, something which I really know nothing about, it's obvious that musicians have used great works of literature, even if it has often been to adapt them, but I can't talk about that, I don't know anything about that area at all.

MA You have, nevertheless, made some lithographs, and only recently four of them illustrated a work by Michel Leiris on bullfighting. I do know, too, that you were very fond of a dark red colour which formed the background of a lithograph made a few years ago. You searched hard to find that colour again, eventually achieving it in a picture you painted some time later.

FB Yes, but that doesn't make any difference. I do not like lithography.
It's a process, it has nothing to do with the adventure of working on a
canvas. As for the colour that you mention, let's say that it is the excep-
tion that proves the rule.

MA But with the price of your paintings, the lithographs are very good
value; they allow people who couldn't buy your pictures and who like
what you do to have some of your work, something which is different
from a poster or a postcard, or a simple reproduction.

FB Perhaps you're right, I don't know.

MA For you then, these meetings of different forms of artistic expression
are of no interest?

FB To be honest, it really doesn't interest me, but that's just what I
think, and in the end the way one proceeds doesn't really matter, the

106 important thing is always to succeed in doing something. That's more important than anything else. If one manages to achieve something in one's life which gives it a meaning, the way in which you achieve it and the area in which you express yourself have no importance at all. As it is, it's so rare to manage to give any meaning to your life, and it's so good if you do succeed.

third conversation

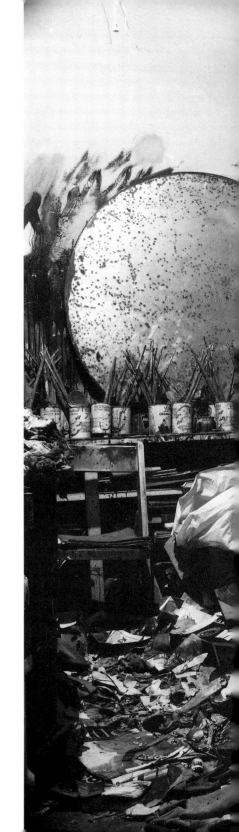

15. Marc Trivier: Francis Bacon's
Studio, London, 1980

16. Marc Trivier: Francis Bacon,
London, 1980 (overleaf)

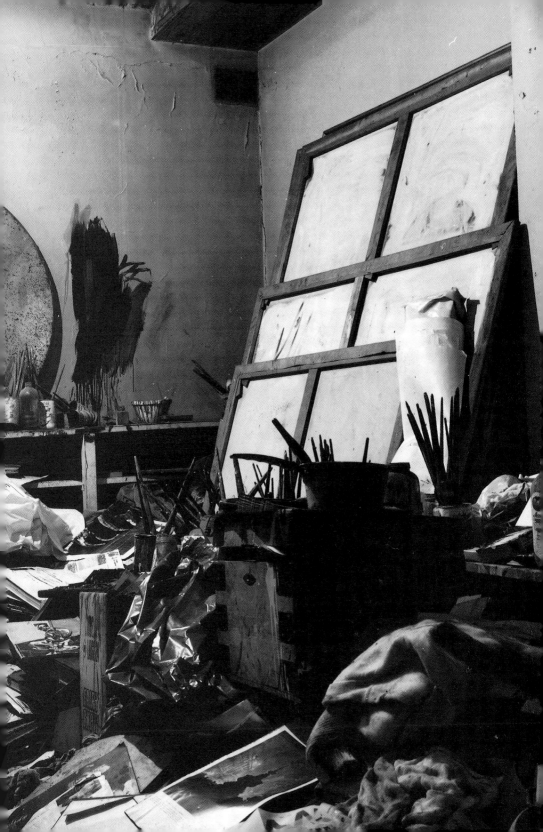

MA The last time we saw each other, we ended our discussion by looking at the relationship between music and painting and, in a more general way, at the possibility of there being a connection or even a merging of the different arts. These interactions between different fields of expression didn't seem obvious to you, except perhaps for opera.

FB Yes, that's right.

MA You did, though, underline the importance that literature has always had for you, not as raw material for illustration, such as Matisse and Picasso did in their time, but perhaps in a more radical fashion as a stimulus for creation.

FB Yes, but I do appreciate what Picasso was able to do with *Le Chef-d'oeuvre Inconnu* by Balzac, for example. His etchings and drawings are not simply illustration, they are something much more than that to me. They really are wonderful.

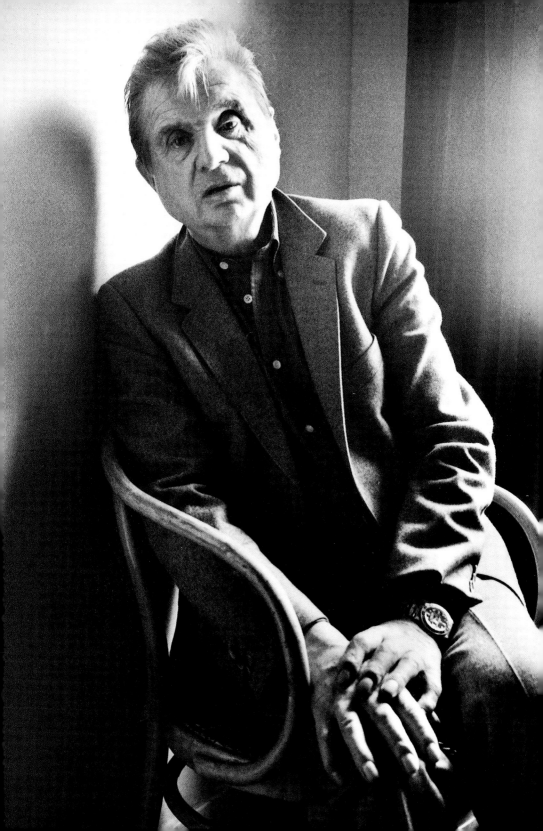

MA I'd like to ask you some questions about literature and what you enjoy reading. You mentioned that the Greek tragedians and Shakespeare have been a source of inspiration for your work. What other works besides these have had a similar effect on you?

FB Well, I always tend to read the same sort of thing. I re-read a lot. I've always had a bad memory and it hasn't got any better as I've got older. It's actually got worse. I re-read Aeschylus all the time, but unfortunately in translation. As I don't read Greek, which really is one of my great regrets, I don't know if I'm reading exactly what Aeschylus wrote. One of my friends is very good at ancient Greek, and he's always told me that you really must understand the language in order to read and appreciate Aeschylus correctly, or any other great tragedian for that matter. That raises the problem of translation. I am inclined to believe this friend of mine because when I manage to read French authors in the original, I realize the discrepancies when I later read them in English. The transition from one language to another is really problematic. The more you read

of a great writer of prose or poetry, the more difficult it is to translate. I've read Racine, Baudelaire, Rimbaud and Proust in French, but I know that I don't understand your language well enough to read your great works of literature in a satisfactory way. You need a sophisticated knowledge of the language to read poetry or even the prose of Proust in French. At the same time, one loses a considerable amount in translation. One sets out, for example, to translate Racine into English, only to find it's absolutely impossible. Nor can you really translate the great English poets into French. However good the translators, I don't think that one can understand Shakespeare in translation. It's quite impossible.

MA You've just mentioned the Greek tragedians, Shakespeare, Racine, Baudelaire, Rimbaud and Proust; they are all classic authors. Do you read any contemporary authors?

FB Yes, some, but not very many; I tend to read less now than I used to.

MA You knew Marguerite Duras, didn't you?

FB Yes, I met her through Sonia Orwell who was very close to her.

MA Have you read her books?

FB No. I saw the film by Resnais, *Hiroshima Mon Amour*, which is taken from one of her scripts. I've heard about *L'Amant*; I know it's a book which has aroused enormous enthusiasm. It was a great success in France, wasn't it?

MA Yes, indeed; it was one of the great publishing successes of the eighties. It sold extremely well and has been translated into I don't know how many languages. Then the film was released and the book did very well again.

FB Yes, so I understand.

MA You know, I have a friend in Paris who thinks that other works by Duras, particularly *Un Barrage sur le Pacifique*, were much better books than *L'Amant*, and he jokes that that book has been so successful because it is printed in large type and it isn't too thick. People don't have much time for reading these days, so that, according to him, explains the success of *L'Amant*. At one time, everyone was talking about the book without really knowing why. It was a sort of snobbery. One just had to have read it.

FB Yes, that's what happens these days. There are fashions, one thing then another, then something else. People are passionate about something, then it's forgotten.

MA Absolutely. These fashions come and go more and more quickly. They almost follow the pattern of the *prêt-à-porter* or *haute couture* collections with a new one every six months.
But to come back to contemporary writers, have you read or seen

any Samuel Beckett? Like you he was Irish, and people have mentioned his name in their search for a literary equivalent of your work.

FB I've always been amazed at this comparison between Beckett and myself. For a start, you can't really say that I'm Irish. It is true that I was born in Ireland and that there are some things that I like about Ireland, especially the way people construct their sentences. There are some very great Irish writers and poets such as Synge and Yeats. Perhaps I share with the Irish a certain desperate enthusiasm. Also, I suppose I've always cherished certain memories of the time when I lived in Ireland as a child. But my parents were English and I spent my childhood between England and Ireland. Beckett lived much longer in Ireland than me, or at least I think he did.

MA Yes, but he also lived in London and then he went to settle in Paris. You've also lived in France, haven't you?

FB Yes, but apart from these two coincidences, I don't see what we have in common. True, I don't know his work well. I have seen *Waiting for Godot* which I didn't by the way find very interesting, and some of his shorter plays which were, in my opinion, much better. There was a very good actress here in London who performed in them. Beckett often used to write for her. Unfortunately, I no longer remember her name. They were very short pieces, not more than half an hour long, barely twenty minutes, and they weren't bad at all. But if you want my opinion, I've always found that Shakespeare expresses what Beckett and Joyce were trying to say more poetically, more accurately and in a much more powerful way. To succeed in expressing the maximum of things by the minimum of means you must be very good, you must have a very reliable instinct and be very inventive; even Shakespeare didn't always achieve it. There are some terribly boring bits in his work. I think Beckett has tried to say a lot by cutting as much as possible in order to leave nothing superfluous. The approach is interesting. Usually in painting you always leave too much in, you never cut enough out, but with Beckett I

often get the impression that because he wanted to hone down his text, nothing was left, and in the end his work sounds hollow and completely empty. He wanted to make a complicated idea simple; the idea may have been a good one but I wonder if, in his case, the cerebral didn't take too much precedence over the rest. It's almost the same as my impression of Seurat, which we've talked about. I wonder if Beckett's ideas about his art didn't end up by killing his creativity. At the same time there's something too systematic and too intelligent about him, which is perhaps what's always made me uncomfortable.

MA And you don't think that your work could conjure up a Beckettian world, or that one could establish some connection between the general atmosphere of your painting and the work of Beckett, just as Didier Anziey demonstrates in the book which I brought for you?

FB I know that this is what certain people think and say, but frankly I don't really see how what Beckett wanted to do has a connection with

what I have wanted to do. From what you've said, this book which you've given me will outline the comparisons between his work and mine. I'm a little sceptical, but I will read it – I'm intrigued.

MA So, for you the greatest source of inspiration is still Shakespeare?

FB Yes, probably because English is my mother tongue, even though I do love to read French authors, despite my limited vocabulary. But I must admit that I always come back to Shakespeare. He has written such exceptional lines. Take the last great speech of Macbeth, those very famous lines on death and the transience of life, on time which passes and has no meaning at all any more. A passage like that is quite extraordinary and there are so many others which are just as impressive. But I've been equally impressed by other texts. The *Oresteia* by Aeschylus is also absolutely incredible. It's just that with Shakespeare I have a sort of familiarity which comes from a story that my father used to tell. When I was young, people used to ask all sorts of questions about

the exact identity of Shakespeare. I think that this is no longer the case today. Amongst all the people whom they thought might have masqueraded behind the name of Shakespeare was the Francis Bacon who lived at that time, and to whom my family is related, according to my father. He was a tremendous chap, probably the only Renaissance man we really had here in England. He was a politician, scientist, philosopher and inventor all at the same time, entirely in the spirit of the great figures of the Renaissance. He almost invented the refrigerator. He tried to put chickens in ice to preserve them. He really was an astonishing person. Queen Elizabeth I loathed him, but he took no notice; he was a free spirit. Perhaps my father's story about this genius busybody helped to make Shakespeare all the more familiar to me, but I realize that all this is just a story. I've always read a lot of Shakespeare and he is one of the writers who has inspired me to produce some of my best work.

MA You've done some paintings from the mask of William Blake. This mask wasn't a death mask, but was a cast taken from Blake's face when

he was still alive. Is Blake, like Shakespeare, one of the writers you find
inspiring? Is he one of the poets you like?

FB No, not particularly. But having said that, I do find that his poetry is better than his painting or his drawing, which I really don't like at all. It's the pictorial aspect of his work I really dislike. I loathe this mystical side of him as much in his painting and his drawing as in his poetry. As you already know, I don't like anything which comes too close to religion.

MA So why did you do these paintings?

FB There's a very simple answer. Someone gave me the head of Blake which you can see there, and I did three different versions from it, but that wasn't a homage to the work of Blake, because his work doesn't really mean anything to me at all. Rather, it was the image itself which inspired these paintings. I do find that images more often than words give me an idea or release my creative block. This model was also

suggested to me at a time when it could help me in my work, just as photographs have done.

MA During our previous conversation, I mentioned a group of four lithographs which illustrate a work by Michel Leiris on bullfighting, a work which sadly he was not quite able to finish. Leiris stands somewhat apart from the other contemporary writers you've known. You enjoyed a long and close friendship with him. Can you tell me a little about him?

FB Certainly. The first thing I'd like to say about him is that the French have never given him the recognition he deserves. I think he's a very great writer and he's still little known in France, which is a pity. I met him on several occasions through Sonia Orwell who knew them, him and his wife Louise, through Merleau-Ponty, I think. When he came here to London for the Giacometti exhibition at the Tate Gallery, Sonia or perhaps David Sylvester himself, asked him over dinner, who in his opinion could translate into French the conversations that Sylvester and I had

had. A short time later, he suggested doing it himself saying that the idea appealed to him. I was incredibly lucky because he did a magnificent translation, possibly better than the original. He put into it all his feeling and all his instinct and he managed to give it a much more profound meaning than I had been able to express. It's extraordinary; I felt myself to be much more intelligent when I read it. I didn't think I had said such things. It's because he is a great writer, and it's probably the only case in which a translation is possible; when it's a writer, a real writer, who does it.

I liked Michel Leiris very much. He was a wonderful friend and an incredibly inspiring man. He had a real knowledge of painting, a sort of sixth sense. He admired Picasso enormously. He once said to me, 'For me, Picasso is a beacon of light.' Picasso illuminated everything for him. I wasn't as enthusiastic as him because, as I've already said, there were many things I didn't like about Picasso, but Leiris liked his entire oeuvre. He liked Giacometti a lot, but I think that Picasso was always the absolute master. There may also have been the question of age. I think there

were almost twenty years between the two, and Picasso was very much the revered older man; he was unbeatable.

But my problem with Leiris, as with other French friends, is my patchy and inadequate grasp of your language. I've learned it bit by bit through my enthusiasm for France, but because I think you can only talk about your work in your own language, or at least in a language you have totally mastered, I've always felt that the conversations I have in French would be limited. I've really regretted it, particularly with Leiris. The same goes for his books. He's written some works which I admire very much, such as *La Règle du Jeu* or *L'Age d'Homme* and a really remarkable text on my own work, but when he gave me the text to read in French, I remember that I had difficulty in grasping the depth and all the nuances. I have a similar problem with French people. Leiris had a very good friend, the poet Jacques Dupin, whom I liked very much and whom Leiris admired, but yet again the obstacle of language prevented me from fully appreciating his work.

MA As for reading, do you prefer prose or poetry?

FB Let's just say that I find everything is expressed in a more compact and precise way in poetry, which is why I prefer reading poetry to prose. But I've also read great prose writers.

MA French writers?

FB Yes, some French ones.

MA Have you read Balzac in French, as well as Proust?

FB Yes. I've also read Proust in English, but it's not at all the same thing. What I really admire about him is the way in which he analyses behaviour, particularly jealousy. As for Balzac, I mentioned just now what Picasso did with *Le Chef-d'oeuvre Inconnu*. You remember the etchings and drawings he did for that book, well, they're a good example of the

influences which work on you, which make you think and which generate new works. In art it's an endless chain. Knowledge isn't cumulative, as it is in science. Proust was no more profound than Balzac, he just expressed things differently. It's a matter of style. And the same is also true of painting. One cannot say that Picasso is better than Cézanne. In science one thinks that what comes later is more valid than what came before. It isn't at all the same in art; there isn't the same sense of progress, and actually I'm not even sure that there is in science at the level of research and discoveries.

MA Braque used to say, 'Echo replies to echo, everything reverberates.'

FB Yes, that's it, that's a fine quotation, because to create something is exactly that: it's a sort of echo from one artist to another.

MA Could you accept this as a good definition of the artistic process?

FB Yes, but I wouldn't know how to explain it to you. Since I most **127**
definitely do not have an orderly mind, it's by a sort of process of contin-
uous rejection that I manage to create something. Both things are valid:
echo and rejection. It's a combination of everything that I don't like and
everything that influences me which contributes to what I do.

MA We were talking about Leiris. He was part of the Surrealist
movement, between 1924 and 1929. Were you influenced either by
Surrealist writers or painters?

FB No, I've never liked Surrealist painting. I'm not interested in Dali or
Ernst. I think that it's the writers of this movement who were the best. All
the texts, manifestos and reviews that they wrote, dreamed up and
published and the great interest in reading and writing amongst Breton
and his circle – that, in my opinion, constitutes the most interesting
aspect of Surrealism.

MA In 1936, you were not accepted for a Surrealist exhibition?

FB That's true; my pictures were in fact refused because they were not sufficiently Surrealist, according to the organizers. I myself think that my pictures were not at all Surrealist! As a matter of fact, my relationship with Surrealism is a little complicated. I think that I've been influenced by what the movement represented in terms of revolt against the establishment, in politics, religion and the arts, but my pictures haven't really shown any direct influence. Well, perhaps a little in my early work. Even in *Painting* of 1946. But in the end, my painting certainly has nothing to do with Surrealist painting. With hindsight, one could say that those who turned down my work for the 1936 exhibition were right. I'm not a Surrealist painter.

MA How would you define yourself?

FB Perhaps by what I don't like.

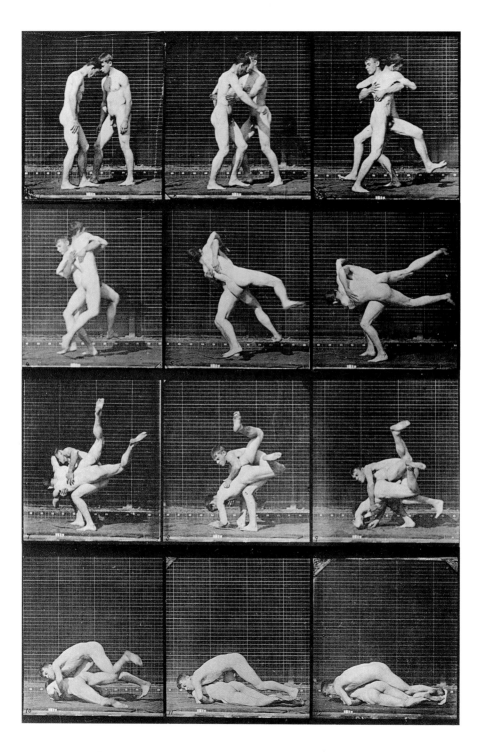

Francis Bacon illustrations

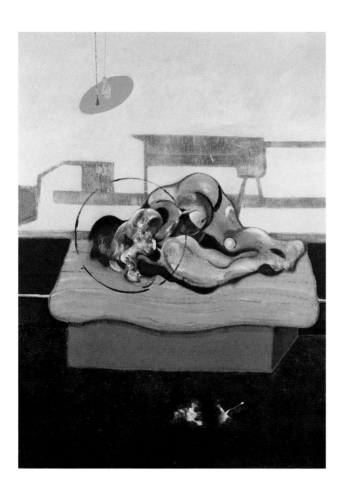

17. Eisenstein: Still from
The Battleship Potemkin, 1925
(previous page)

18. Muybridge: Sequence of
photographs of men wrestling from
**The Complete Human and Animal
Locomotion**, 1887 (left)

19. Francis Bacon: **Three Studies
for Figures on Beds**, 1972 (central
panel above)

20. Picasso: *Figures by the Sea
(The Kiss)*, 1931

21. Cimabue: *The Crucifixion* (flood
damaged), 1272-74 (opposite)

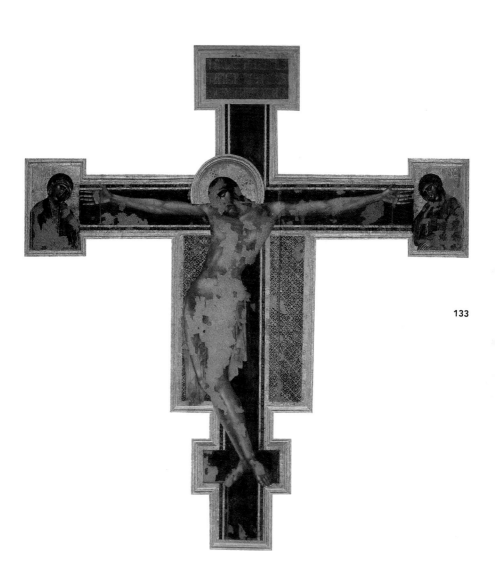

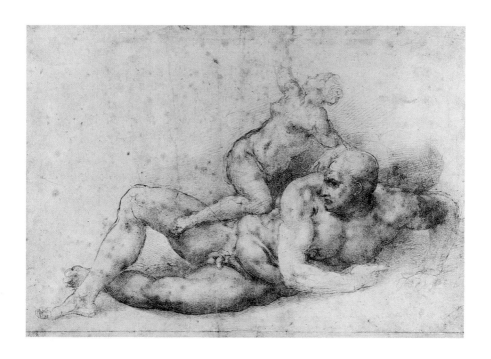

22. Michelangelo: ***Samson and
Delilah***, *c.* 1530

23. Rembrandt: ***Self-portrait***
(detail), *c.* 1660-63 (opposite)

Francis Bacon illustrations

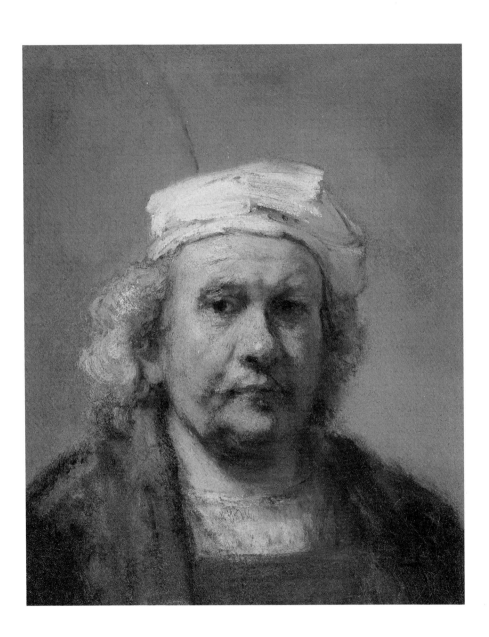

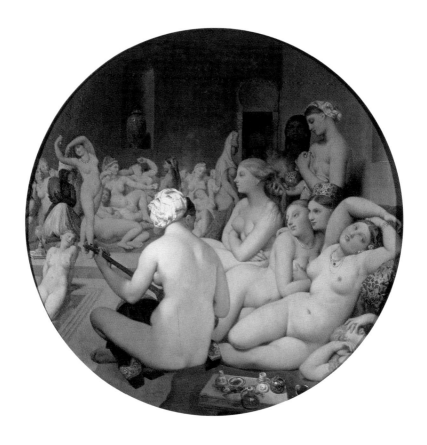

24. Ingres: *The Turkish Bath*,
1859-63

25. Géricault: *Rearing Stallion*
Held by a Man, c. 1817

138

26. Van Gogh: *The Painter on his
Way to Work* or *The Road to
Tarascon*, 1888 (destroyed during
World War II)

27. *Study for Portrait of Van
Gogh VI*, 1957

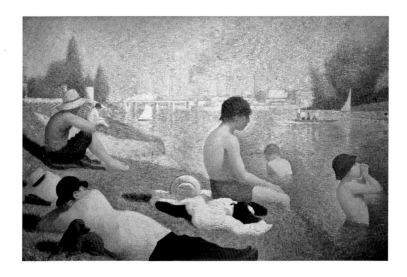

140

28. Degas: **After the Bath, Woman Drying Herself**, 1903 (top left)

29. Seurat: **Bathers at Asnières**, 1883-84 (left)

30. Giacometti: **Portrait of Annette**, 1949 (above)

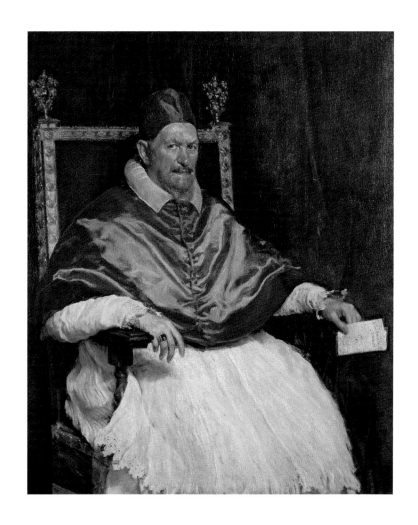

31. Velázquez: *Pope Innocent X*,
1650

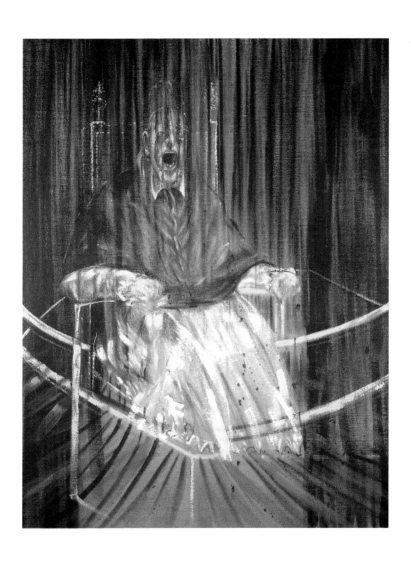

32. *Study after Velázquez's*
Portrait of Pope Innocent X, 1953

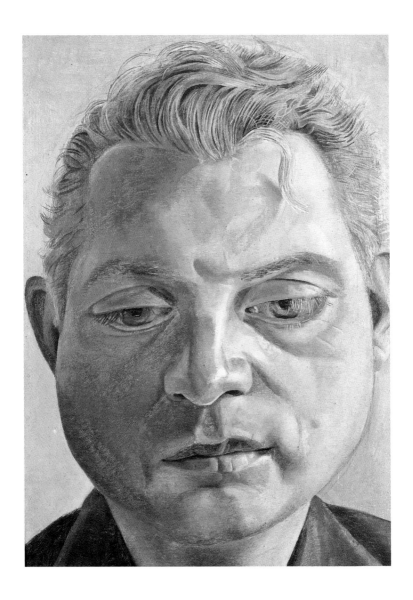

31. Lucian Freud: **Portrait of Francis Bacon**, 1952

MA Apart from Surrealism, what else don't you like in painting? Abstraction?

FB Yes, abstract art seems to me an easy solution. Painting materials are in themselves abstract, but painting isn't only the material, it's the result of a sort of conflict between the material and the subject. There's a kind of tension there, and I feel that abstract painters eliminate one of the two sides of this conflict right from the start: the material alone dictates its forms and its rules. I think that that is a simplification. I also find that the human figure with its constant changes is very important. Abstraction has never been enough for me; it has never satisfied me. It seems to me that abstraction basically reduces painting to something purely decorative.

MA You would rate figurative painting above landscape?

FB Yes, but that makes perfect sense to me. As a human being, I'm

146 more interested in the representation of people.

MA And within the realm of figurative painting are you particularly interested in self-portraits?

FB No, not particularly. I've done many portraits of friends. I have to know them well, and be able to observe them for a long time.

MA But at one time you did a lot of self-portraits?

FB Yes, when I couldn't find other models I did paint myself, but that was for want of something better, not because I found it more interesting in itself.

MA There is, nevertheless, a distinguished tradition of the self-portrait in painting?

FB Yes, that's right.

MA And don't you think that the self-portrait is the essence of figure painting?

FB No, I don't think so. It's a model just like any other. The important thing is always to succeed in grasping something which is constantly changing, and the problem is the same whether it's a self-portrait or a portrait of someone else.

MA You said a while ago that for you the image probably has more power than anything else. What kind of images were you thinking of when you said that?

FB I don't know; I look at everything. Life unfolds before your eyes and you look at it, that's all. You are bombarded by images all the time. There are only a few, though, which stick in your mind and have some

influence, but some do have a considerable effect. It's difficult to say anything about this effect because it isn't so much the image which matters, but what you do with it, and what effect some images have on other images. It's possible, for example, that the fact of having seen the image of the Sphynx could change your way of seeing a man who passes you in the street. I think that every image, everything we see, changes our way of seeing everything else. My perception is completely altered. Certain images, perhaps even everything that I see, might imperceptibly modify all the rest. There's a sort of influence of image upon image; it's a great mystery, but I'm sure that that's what happens.

MA While we were talking about Marguerite Duras's book we mentioned the phenomenon of fashion which governs our societies more and more, in terms of economic and cultural choices. In your opinion, what place does the artist occupy in society today?

FB I can only answer that question in the light of my own experience,

which has always been that of a solitary person. Some artists have
perhaps needed to create movements or attach themselves to a school
or a trend. As for me, I actually have difficulty in finding artists to talk to,
at least here in England. The problem doesn't apply in other countries
because of the language barrier. There are also some artists who like to
be near those in power. There are many examples in our century, and not
only second-rate artists; Picasso joined the Communist Party. I, on the
other hand, have always been completely alone. So I'd be inclined to say
that I see the artist more as a loner in the society in which he lives.

MA But if I understand correctly, for you being alone doesn't necessarily
mean being indifferent to what others are producing around you?

FB Given that one lives in a certain society at a certain time, of course
one is always involved in the events of one's age.

MA Do you follow politics?

FB Not very closely, but if you read the newspapers you can't help but be aware of what goes on.

MA What feelings do you have in general about current political life?

FB I was born in 1909. Since then there have been dozens of wars and conflicts all over the world, beginning with the events in Ireland and the First World War just after I was born. I feel that people of my generation cannot really imagine human life without war. It's rather a frightening thing to say, but I think it's an experience that many people have had. For them, there has always been war. As for what's happening now … Perhaps the difference today is the media. With radio, television and newspapers, we're told everything that's happening; we hear everything from everywhere. I don't think that makes people more intelligent or that it develops their critical faculties to any greater extent; one might hope so, but I don't feel that it's the case. At any rate, it would be very difficult to remain ignorant of what's happening in the world.

MA Many people are struck by the violence in your work. Do you think that what they see in your work is a reflection of the violence of this century?

FB I'm always very surprised when people speak of violence in my work. I don't find it at all violent myself. I don't know why people think it is. I never look for violence. There is an element of realism in my pictures which might perhaps give that impression, but life is so violent; so much more violent than anything I can do! One is exposed to violence all the time and these days, with the millions of images from all over the world, violence is everywhere and is permanent. I really cannot even begin to believe that my work is violent. But maybe it's the actual word violence that basically I don't understand properly. In a certain sense the Picassos that I like are violent, but not in their subject matter; they are violent in the colours and forms that they use, and it's because these pictures are so remarkably well executed that one could say that they are violent in a certain sense. They are violent because of the incredible emotional

charge which they produce, and that is an impressive sort of violence.

MA It's not a violence that destroys, it's a constructive violence in some way.

FB Yes, that's how I see it. Certain works of Picasso have not only unlocked images for me, but also ways of thinking, and even ways of behaving. It doesn't happen often, but I have experienced it. They released something in me, and made way for something else. Let's say that it wasn't fruitless violence.

MA René Char said, 'If you destroy, then let it be with the instruments of marriage.'

FB Yes, that's it; violence which opens the door to something else. It is rare but that's what can sometimes be produced by art; images can shatter the old order leaving nothing the same as before.

MA So you don't feel, as some people do, that your work is tragic, that it is shrouded in an atmosphere where anguish is pitched against pain and death?

FB Life and death go hand in hand in any case, don't they? Death is like the shadow of life. When you're dead you're dead, but while you're alive, the idea of death pursues you. Perhaps it's normal for people to have this feeling when looking at my paintings. It rather surprises me because on the whole I'm an optimist, but in the end why not?

MA So you are an optimist?

FB I don't have the optimism of a believer, but I sometimes feel happy to be alive, excited at having achieved something, especially since that hardly ever happens; I must admit it's more of a despairing optimism.

MA You're not a believer, but you did receive a religious education?

FB Yes I did, but not much of one, and it lost any meaning very quickly.

MA Could you tell me a bit about your childhood in Ireland?

FB I didn't spend all my childhood in Ireland, far from it. My parents didn't settle. We lived between England and Ireland and we were constantly on the move from one country to the other, or within each country from one house to another. I have remained attached to certain places like my maternal grandmother's house, Farmleigh, where we lived at the end of the First World War.

MA Is that the house where some of the rooms were curved?

FB Yes, in fact all the rooms which overlooked the garden. It was quite a big house. One never really knows, but the use I've made of curved backgrounds in some of my pictures may possibly be a recollection of those rooms.

MA What memories do you have of your father and mother?

FB I don't have many memories of them. I never got on with either of them. I get the impression that they always thought I was rather an odd child, and when I started to talk about becoming a painter, they thought it was a ridiculous idea. Perhaps they were right? Perhaps it was ridiculous?

MA Life has proved you right though.

FB Yes, but it took me a long time before I began to paint regularly, and it may well have seemed odd to my parents that I wanted to become an artist. There was no tradition of artists in the family.

MA You had brothers and sisters. What were your relationships like with them?

FB I had two brothers and two sisters. My two brothers are dead. The first died on the Zambezi, aged twenty-eight, on his way to South Africa where one of my sisters, who is nine years younger than me, still lives. The second died of pneumonia. At that time there was no cure for it and my father was heartbroken at his death. I think it was the only time I ever saw my father show deep emotion. He loved my brother very much, but he never understood me.

MA How did you enjoy your school days?

FB Well, I didn't spend much time at school. I didn't like school at all, and then what with my parents' numerous moves … I taught myself later; I read, either works that people recommended to me or books that I discovered myself, and that's really how I was educated. Studying and school was never for me.

MA And what about painting, have you ever been taught?

FB No, I don't believe in teaching. One learns by looking. That's what you must do, look.

MA But plenty of painters, I'm thinking particularly of Cézanne, Matisse and others, have not been content just to look. When they were still young painters they spent a lot of time copying the work of the Old Masters. The French used to go to the Louvre. You haven't been tempted to do the same thing?

FB No. It's true that many painters have taught themselves in that way, but I didn't. I've never felt the need. I've always believed that one cannot take on the genius of others, unfortunately. Indeed, I have literally been obsessed by works of great painters from the past.

MA Are you thinking, for example, of *Pope Innocent X* by Velázquez?

FB Yes.

MA But that was later, and it wasn't a case of copying, but rather an interpretation on your part of that famous portrait.

FB Yes, perhaps I should have been satisfied with just copying it after all. I tried to re-create it, but I don't think that it worked.

MA But everyone agrees that those canvases are amongst your most important works.

FB Perhaps they are for some people, but not for me. I really consider it a mistake to have done those paintings. I was haunted by that work, by the reproductions that I saw of it. It's such an extraordinary portrait that I wanted to do something based on it. It's an example of what I've already described to you; I was quite overcome by it and I felt compelled to do what I did. I felt overwhelmed by that image. Unfortunately, the result was far from satisfactory.

MA I believe you've never seen the original, is that right?

FB Yes, that's right. When I had the opportunity to see it, during a stay in Rome, I was not at all well. Being ill at the time, I didn't feel that I was in a fit state to go.

MA During the few years that I've known you, I've always had the impression that you were a rather solitary individual, not only in your work, in which you stick to your own path, shying away from fashions and movements, but also in your life. Have you always felt this need for solitude, have you sought it?

FB Yes, I have. I feel as if I've spent most of my life alone, but in fact it depends on circumstances. If I'm working, I don't want to see people. That's why the bell at my studio doesn't work. Someone might ring, but I don't hear it. It's definitely much better for me not to be disturbed while I'm working. Perhaps the one exception I would make would be if I were

seriously in love, but that's an exceptional situation indeed, especially when one gets old.

MA How are your days generally organized?

FB I prefer to work in the morning. Usually I get up early, around six o'clock, and I work until about eleven o'clock or midday; then, after lunch, I take a break. I wander around, I go to pubs, and I admit that more often than not I go alone. I do also sometimes go with friends or with people who have come to see me. I also meet people there who have come, like me, to drink or meet other people, but they aren't friends, they're just acquaintances. On the whole, it's the same as with love; as you get older you see fewer and fewer people, and people are less and less interested in you.

MA You really think that?

FB Yes. Oh, there are people who appreciate my painting, yes … but it's difficult to make friends at my age. What's more, a lot of my friends have died. I've not been very lucky in that respect; many people I loved have died, not only more recently, but before that …

MA But you've certainly had friends all your life. Is friendship important to you?

FB Yes, of course it is, but everything comes second to my work. I've been quite ill for the last few years, the last two in particular, and during that time I was unable to work. I haven't been able to work since then either, and that has certainly reduced my freedom. It all comes down to age and health.

MA You've had asthma all your life?

FB Yes, I have.

MA Do you think that illness has had an influence on your work as people say it did on Proust?

FB I couldn't tell you, but what is certain is that I've always lived with it. It's been with me longer than painting has and it's a daily experience. It is probably something that has influenced my work, but it's impossible for me to say how.

MA You were talking just now about pubs and drinking. Has alcohol helped you in your work?

FB No, I don't think so. When I drink too much I can't work. I know there are some artists who manage it, but not me. It doesn't help me at all. No, I drink both because I like it and also because most of my friends were what you would call great drinkers. From the point of view of painting, alcohol hasn't really been a stimulant, except perhaps on the odd occasion. But most of the time, drinking made it more difficult for me to paint.

MA Amongst all the things that influence your work, how important is place? Can you paint wherever you are?

FB Oh no, I can only paint here in my studio. I've had plenty of others, but I've been here for nearly thirty years now and it suits me very well. I cannot work in places that are too tidy. It's much easier for me to paint in a place like this which is a mess. I don't know why, but it helps me. I think it's the same with my work. When I begin, I might have some ideas, but most of the time the only idea I have is of doing something. There's nothing well-ordered in my head; I respond to some kind of stimulation, to a mark, that's all. If it's going to work, then it happens afterwards on the canvas, as the work progresses. Unfortunately, the result doesn't often live up to the initial excitement. I'm rarely happy with the result, but that's a different problem. This mess here around us is rather like my mind; it may be a good image of what goes on inside me, that's what it's like, my life is like that.

164　　　**MA**　But you sometimes plan your pictures …

FB　Yes, sometimes to begin with, but I usually change my mind very quickly.

MA　If I understand correctly, to paraphrase Picasso, one could say that the painting itself dictates what you do.

FB　Yes, perhaps things did seem like that to him. There's such a richness in his work, it's incredible, but my case is quite different. I don't know if I could say the same about myself.

MA　During one of our conversations last year we talked about the possibility of organizing an exhibition of some of your triptychs. As I was thinking about this, several questions occurred to me about the triptychs and also about the exhibition. First of all, whose work inspired you to create so many triptychs?

FB I've often been asked questions about the triptychs. To tell you the truth, I don't really know. Actually I don't know if one should talk about a triptych in my case. Of course, there are three canvases, and you can link that to a long-standing tradition. The primitives often used the triptych format, but as far as my work is concerned, a triptych corresponds more to the idea of a succession of images on film. There are frequently three canvases, but there is no reason why I couldn't continue and add more. Why shouldn't there be more than three? What I do know is that I need these canvases to be separated from one another. That's why I was so annoyed with the way the Guggenheim mounted the three panels of its *Crucifixion* all in one frame. It was absurd. I wanted them to be separate, and this is also the case for the canvases of the other triptychs.

MA In a way they are sequences?

FB Yes, in one sense they are. One image, another, then another with the frame adding a certain rhythm to the progression of images.

MA Why in 1988 did you remodel your 1944 triptych entitled *Three Studies for Figures at the Base of a Crucifixion*? Why did you go back to that work which to a certain extent, in its first version, is your key work – the one which you consider as having signalled your real debut as a painter?

FB I don't know. I had always intended to rework that painting in a much bigger format, and then one day I decided to do it. But I didn't re-create exactly the same work. It's slightly modified compared to the 1944 version, particularly in terms of colour, as orange predominates in the first version and red in the second.

MA As far as exhibitions are concerned, do you have any particular preferences about the way in which your canvases are hung?

FB Yes, I always prefer my canvases to be in a frame and under glass. There is a current vogue for not framing pictures any more, but I feel that

this is wrong, bearing in mind what a painting is. The frame is artificial and that's precisely why it's there; to reinforce the artificial nature of the painting. The more the artificiality of the painting is apparent, the better, and the more chance the painting has of working or of showing something. That might seem paradoxical, but it makes perfect sense in art: one achieves one's goal by using the maximum of artificial means, and one succeeds much more in doing something authentic when the artificiality is patently obvious. Take for example the Greek or classical poets; their language was very artificial and highly stylized. They all worked within strict constraints, and yet it's precisely in doing so that they produced their greatest works which give us, when we read them, that impression of freedom and spontaneity.

MA Why have you not exhibited for some time?

FB As I told you, I was very ill for a while and even this winter I haven't been well. I haven't been able to work as much as I would have liked.

However, I did paint a new triptych in the autumn and I might have an exhibition next October in Madrid. I'm going to Madrid in a few days' time. We'll see.

FB It's a long time since you had a big exhibition in Paris, not since the one at the Grand Palais in 1971 in fact. Would you like to show in Paris again?

FB Yes, it would give me a good excuse to make the journey. It isn't because you are French but, of all the countries I know, France is my favourite. I enjoyed Monte Carlo and I love Paris so much that when I had a studio there, I couldn't work as much as I should have because I went out all the time, just to look at the town. Here in London I don't really have any urge to go out. I should say that I do know London better and so, as far as work is concerned, I'm less tempted. I do go regularly to Paris to see exhibitions or to stroll around. I also used to go and see Michel Leiris every time I was there.

MA Paris has changed a lot recently. Do you still like it as much?

FB Yes, it really is a very beautiful city. Actually, I don't find that the colonnade they've created at the Palais-Royal works very well, but I like the Grand Louvre with the new esplanade and the Arche de la Défense at the other end. In a way, they've followed the layout of Paris.

But travelling is getting more difficult for me and some of my friends in Paris have died, including Leiris, and that certainly makes things a little different.

MA Not long ago there was a big retrospective of your work in New York. Why didn't you go?

FB Well, it depends how you feel at the time of these events. And also, it's not very easy to know how your own work will look to you, hanging there before your eyes. My memories of these kinds of events vary and sometimes I find what I've done is somewhat mediocre, worse than

anything else, and that's why I don't always want to go and see my exhibitions. But it's a feeling that I also get with other people's work. You have to be in a certain mood in order to look, and your perception varies according to the mood you're in.

MA So in short, all perception is relative?

FB Yes, it's always like that when you look at a picture. But each person, of course, translates it in his own way. The effect that the portraits by Ingres have on me is quite different from their effect on someone else, and it's not just because I'm a painter and the other person isn't. It's the same with the face of someone you pass in the street. You get an impression and you can make all sorts of analyses based on these impressions and someone else, seeing the same face, will come to a totally different conclusion. It's all very mysterious. The same goes for orange, which is my favourite colour; I couldn't explain in any satisfactory way the reasons why I find it such a beautiful colour.

MA What you're saying then makes all criticism fraught with difficulty and exceedingly problematic.

FB Yes, but I do think that it is very difficult to talk about painting anyway. That has always seemed to me to be the case and perhaps even more so now. Painting is a world of its own, it's self-sufficient. Most of the time when one talks about painting, one says nothing interesting. It's always rather superficial. What can one say? Basically, I believe that you simply cannot talk about painting, it just isn't possible.

MA Yet you've managed to do it very well, and I'm not just thinking of our conversations.

FB But that's because I'm talkative, it's the Irish in me. But frankly, I don't think it's possible and even if it were, it's not what's important. The important thing for a painter is to paint and nothing else.

172 **MA** Paint at every opportunity?

 FB Yes, even if they're only copies, a painter should paint.

Biographical notes

1909
28 October. Birth of Francis Bacon in Dublin to English parents. He is the second of their five children. His father is a breeder and trainer of racehorses.

1914–25
With the declaration of war, the Bacon family move to London. They then move back and forth between England and Ireland. Francis Bacon, who suffers from asthma, receives lessons from a private tutor. At the age of sixteen he leaves his family and goes to London where he earns a living by doing odd jobs.

1927–28
Travels to Berlin, then to Paris where he does some decorating jobs. The Picasso exhibition at the Paul Rosenberg Gallery determines his vocation as a painter.

1929
After returning to London, he exhibits some furniture and begins painting in oils. He gradually abandons his activities as a decorator in order to

devote himself to painting and maintains his living by doing various odd jobs. Meets Eric Hall.

1933 Takes part in two group exhibitions and paints some *Crucifixions*.

1934 One-man exhibition at the Transition Gallery which he organizes himself and which has little success.

1936 Rejected for the international Surrealist exhibition: the work submitted is 'not sufficiently surreal'.

1937 Takes part in the group exhibition 'Young British Painters' organized by Eric Hall.

1941 For a while leaves London for the country.

1942–44 Returns to London. Turned down for military service because of asthma, assigned to Civil Defence (ARP). Destroys most of his works.

176

1944 Begins to paint again, notably *Three Studies for Figures at the Base of a Crucifixion* which will be acquired by the Tate Gallery in 1953.

1945 Group exhibition at the Lefevre Gallery. The *Three Figures Cause an Uproar*. Also exhibits *Figure in a Landscape*.

1945–50 Takes part in several group exhibitions. Frequently stays in Monte Carlo. One-man exhibitions at the Hanover Gallery in London, which is to be his dealer for the next ten years. Begins to paint the series of *Heads*. In 1948 Alfred Barr purchases *Painting* (1946) for the Museum of Modern Art in New York. In 1950 visits his mother in South Africa and spends a few days in Cairo.

1951–55 Several changes of studio. Numerous group exhibitions. In 1951 begins to paint his first *Popes*. In 1952 goes again to South Africa. In October–November 1953, first one-man exhibition abroad,

at Durlacher Brothers in New York. In 1954 he paints the *Men in Blue* series. Represents Great Britain, with Lucian Freud and Ben Nicholson, at the XXVII Biennale in Venice. Does not go to the Biennale, but visits Ostia and Rome. Because of illness, he does not go to see the portrait of *Pope Innocent X* by Velázquez which in reproduction has inspired his *Popes*.

1955 First retrospective of his work at the Institute of Contemporary Arts in London. Group exhibition at the Hanover Gallery where he shows portraits of William Blake. Numerous group exhibitions in the United States.

1956 First voyage to Tangier, in the summer, to visit his friend Peter Lacey. He rents a flat where he will stay frequently during the next three years.

1957 First exhibition at the Galerie Rive Droite in Paris. Shows his *Van Gogh* series at the Hanover Gallery.

1958	Retrospective of his work in Turin, then Milan and Rome. On 16 October, signs a contract with the Marlborough Fine Art Gallery in London. Represents Great Britain at the Carnegie Institute in Pittsburgh.
1959	Shows at the V Biennale in São Paulo. Group exhibitions in Paris, New York and Kassel.
1960	First exhibition at the Marlborough Gallery.
1962	First large triptych *Three Studies for a Crucifixion* acquired by the Solomon R. Guggenheim Museum in New York. Big retrospective of his work at the Tate Gallery in London, which moves on with some changes to Mannheim, Turin, Zurich and Amsterdam. Death of Peter Lacey.
1963–64	Retrospective at the Solomon R. Guggenheim Museum in New York, then at the Art Institute in Chicago and the Contemporary Art Association in Houston.

1964 Liaison with George Dyer. Paints the large triptych *Three Figures in a Room* which will be acquired by the Musée National d'Art Moderne in Paris.

1965 Paints his large *Crucifixion* triptych acquired by the Munich Museum.

1966 Winner of the Rubens prize from the town of Siegen, in West Germany. Shows at the Galerie Maeght in Paris, attends the opening.

1967 Galerie Maeght exhibition goes to the Marlborough Galleria d'Arte in Rome, to Milan and to the Marlborough Gallery in London.

1968 Stays briefly in New York for the opening of the exhibition of his recent paintings at the Marlborough-Gerson Gallery.

1971–72 Important retrospective at the Grand Palais in Paris. Death in Paris of his friend and model

George Dyer. In his memory he paints the large *Triptych 1971*. In March 1972 the retrospective from the Grand Palais goes to the Kunsthalle in Düsseldorf.

1975 Big exhibition of his recent paintings at the Metropolitan Museum of Art in New York. Goes to New York for the occasion.

1976 Shows at the Musée Cantini in Marseilles.

1977 Exhibition at the Galerie Claude Bernard in Paris. Attends the opening. Exhibition at the Museo de Arte Moderno in Mexico, then at the Museo de Arte Contemporáneo in Caracas.

1978 Exhibitions in Madrid and Barcelona.

1980 The Tate Gallery buys his *Triptych August 1972*. Shows at the Marlborough in New York.

1983 Exhibition in Japan, in Tokyo, Kyoto and Nagoya.

1984 Shows at the Galerie Maeght Lelong in Paris.
 Exhibition of his recent works at the Marlborough
 Gallery in New York. Brief stay in New York.

1985–86 New retrospective of his work at the Tate Gallery in
 London. The exhibition then goes to the
 Staatsgalerie in Stuttgart and the Nationalgalerie
 in Berlin. Visits Berlin with his friend John Edwards.
 Paints a large *Self-portrait* in triptych form.

1988 Shows in Moscow at the Central House of Artists of
 the New Tretyakov Gallery. Paints a second version
 of the 1944 triptych. *Three Studies for Figures at
 the Base of a Crucifixion.*

1989–90 Exhibition at the Smithsonian Institute in
 Washington, which then goes to the Los Angeles
 County Museum of Art and to the Museum of
 Modern Art in New York.

1990–91	Exhibition at the Tate Gallery in Liverpool.
1992	April. Goes to Spain to meet some friends. Dies in Madrid, 28 April, from a heart attack. Exhibition at the Galeria Marlborough in Madrid.
1993	Exhibitions at the Museo d'Arte Moderna in Lugano; the Marlborough Gallery in New York and the Museo Correr in Venice.

Bibliography

Ades, Dawn and Forge, Andrew, *Francis Bacon*, London, 1985.

Bacon, Opus International, no. 68, Paris, 1978.

Davies, Hugh and Yard, Sally, *Francis Bacon*, New York, 1986.

Deleuze, Gilles, *Francis Bacon: Logique de la Sensation*, Paris, 2 vols, 1981.

Dupin, Jacques, *Notes sur les dernières peintures*, Cahiers d'art contemporain, no. 39, Galerie Lelong, Paris, 1987.

Francis Bacon, Art International, no. 8, Paris, Autumn 1989.

Francis Bacon Retrospective Exhibition, MOMA, New York, June 1990.

Gowing, Lawrence and Hunter, Sam, *Francis Bacon*, Washington D.C., 1989.

Leiris, Michel, *Francis Bacon ou la vérité criante*, Paris, 1974.

Leiris, Michel, *Francis Bacon: Full Face and in Profile*, London, 1983.

Rothenstein, Sir John, *Francis Bacon*, London, 1963.

Rothenstein, Sir John and Alley, Ronald, *Francis Bacon*, catalogue raisonné, London, 1964.

Russell, John, *Francis Bacon*, Series 'Art in Progress', London, 1964.

Russell, John, *Francis Bacon*, London, 1971.

Russell, John, *Francis Bacon*, London, 1979.

Schmied, Wieland, *Francis Bacon: Vier Studien zu einem Porträt*, Berlin, 1985.

Spécial Francis Bacon, Artstudio, no. 17, Paris, June 1990.

Sylvester, David, *Interviews with Francis Bacon*, London, 1975.

Zimmerman, Jörg, *Francis Bacon: Kreuzigung*, Frankfurt, 1986.

List of illustrations

7. ***Three Studies for a Crucifixion***, 1962. Triptych.
Oil on canvas, each panel 198 × 145 cm.
The Solomon R. Guggenheim Museum, New York.

8. ***Study from Innocent X***, 1962.
Oil on canvas, 198 × 141.5 cm.
Private collection.

9. ***Study for Bullfight No. 1***, 1969.
Oil on canvas, 198 × 147.5 cm.
Private collection.

10. ***Three Studies for Figures on Beds***, 1972. Triptych. Oil and
pastel on canvas, each panel 198 x 147.5 cm.
Private collection.

11. ***Three Studies for Self-portrait***, 1979. Small triptych.
Oil on canvas, each panel 37.5 × 31.8 cm.
Private collection.

12. ***Second Version of Triptych 1944***, 1988. Triptych.
Oil on canvas, each panel 198 × 147.5 cm.
Tate Gallery, London.

13. Marc Trivier: Photograph of Francis Bacon's Studio, London, 1980.

14. Daniel Farson: Photograph of Francis Bacon and Lucian Freud in Bacon's studio, 1953.

15. Marc Trivier: Photograph of Francis Bacon's Studio, London, 1980.

16. Marc Trivier: Photograph of Francis Bacon, London, 1980.

17. Sergei Eisenstein: Still from **The Battleship Potemkin**, 1925.

18. Eadweard Muybridge: Sequence of photographs of men wrestling from ***The Complete Human and Animal Locomotion***, 1887.

19. **Three Studies for Figures on Beds**, 1972. Triptych (central panel). Oil and pastel on canvas, each panel 198 × 147.5 cm. Private collection.

20. Pablo Picasso: **Figures by the Sea (The Kiss)**, 1931. Oil on canvas, 130.5 × 195.5 cm. Musée Picasso, Paris.

21. Cimabue: **The Crucifixion** (flood damaged), 1272-74. Oil on panel 448 × 389.9 cm. Chiesa di Santa Croce, Florence.

22. Michelangelo Buonarroti: **Samson and Delilah**, c. 1530. Red chalk, 27.2 × 39.5 cm. Ashmolean Museum, Oxford.

23. Rembrandt van Rijn: **Self-portrait** (detail), c. 1660-3. Oil on canvas, 114 × 94 cm. Kenwood House, London, The Iveagh Bequest.

24. Jean-Auguste Dominique Ingres: **The Turkish Bath**, 1859-63.
Oil on canvas and panel, 108 cm diameter.
Louvre, Paris.

25. Theodore Géricault: **Rearing Stallion Held by a Man**, c. 1817
Pencil drawing, 20.5 × 28.5 cm.
Private collection.

26. Vincent Van Gogh: **The Painter on his Way to Work** or
The Road to Tarascon, 1888.
Formerly in the Kaiser-Friedrich Museum, Magdeburg.
(Destroyed during World War II.)

27. **Study for Portrait of Van Gogh VI**, 1957.
Oil on canvas, 202.5 × 142 cm.
Arts Council of Great Britain, London.

28. Edgar Degas: **After the Bath, Woman Drying Herself**, 1903.
Pastel, 104 × 99 cm.
National Gallery, London.

29. George Pierre Seurat: *Bathers at Asnières*, 1883-84.
Oil on canvas, 200 × 300 cm.
National Gallery, London.

30. Alberto Giacometti: *Portrait of Annette*, 1949.
Pencil drawing, 48 × 31.5 cm.
Galerie Beyeler, Basle

31. Velázquez: *Pope Innocent X*, 1650.
Oil on canvas, 140 × 120 cm.
Galleria Doria Pamphili, Rome.

32. *Study after Velázquez's Portrait of Pope Innocent X*, 1953.
Oil on canvas, 153 × 118 cm.
Des Moines Art Center, Coffin Fine Arts Trust Fund.

33. Lucian Freud: *Portrait of Francis Bacon*, 1952.
Oil on metal, 17.8 × 12.7 cm.
Tate Gallery, London.

Photographic acknowledgements

All works by Francis Bacon and plate 14 are reproduced by kind permission of Marlborough Fine Art Limited, London; frontispiece © Richard Avedon 1979; plates 21, 24, 25, 29 and 33, Bridgeman Art Library; plate 18, Muybridge Collection, Kingston Museum, Kingston-upon-Thames; and plate 20, Photo R. M. N., Paris.